IMAGES
of America

LODI

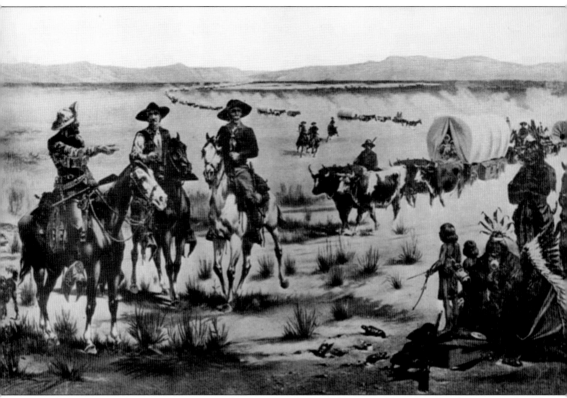

This painting depicts pioneers traveling to join the California Gold Rush. The discovery of gold at Sutter's Mill in 1848 hastened the development of California's interior. Situated only miles from the gold fields and at the head of the fertile San Joaquin Valley, Lodi became an ideal location for settlers during the development of California's next great industry after mining—agriculture. (Bank of Stockton Historical Photograph Collection.)

ON THE COVER: Crowds watch the procession of Lodi's first Tokay Carnival parade. An electric trolley car sits beside a newly constructed mission-style arch built to serve as an entrance to the city. This single event forged an identity for the new city and continues today as the Lodi Grape Festival and Harvest Fair held every September. (Celia Crocker Thompson Collection.)

IMAGES
of America

LODI

Ralph A. Clark

ARCADIA
PUBLISHING

Published by Arcadia Publishing
Charleston SC, Chicago IL, Portsmouth NH, San Francisco CA

Printed in the United States of America

Library of Congress Control Number: 2009920009

For all general information contact Arcadia Publishing at:
Telephone 843-853-2070
Fax 843-853-0044
E-mail sales@arcadiapublishing.com
For customer service and orders:
Toll-Free 1-888-313-2665

Visit us on the Internet at www.arcadiapublishing.com

To my Sarah, who believed in me and this book the whole way through.

CONTENTS

ACKNOWLEDGMENTS

This project required a great amount of kindness and collaboration from many sources, and thankfully I received an abundance of both. Gratitude goes to William Maxwell and Angela Brusa of the Bank of Stockton; without their help this project would not have happened.

Special thanks go to Sandy Smith and the entire staff of the Lodi Public Library, who provided enormous help, information, and unprecedented access to their photograph collection. They are one of the best library staffs I have ever worked with.

My appreciation goes to former mayor, author, and historian Steve Mann for the generous use of his historic postcard collection and for his immense knowledge of Lodi history, and to Leigh Johnsen and David Stuart of the San Joaquin County Historical Society and Museum; their permission to use selected photographs from their tremendous archives is much appreciated.

Gratitude goes to Peter Knight, owner of the Lodi A&W Restaurant, and to Larry Pilmaier of Woodbridge Winery for their contributions to the book, and to my editor, John Poultney, who weathered the various starts and stops of this project and the frustrating difficulties with tact.

I have a sincere appreciation for all the writers, historians, and photographers who came before me, including George Tinkham, Celia Crocker Thompson, Maurice Hill, Warren Hicks, Freda Nesbit, Bessie Lewis, Leonard Covello, Ralph Lea, Naomi Carey, Janice Roth, Nancy Schmer, Lucy Reller, Valdene Valenti, and Christi Kennedy, whose work inspired me to value and understand my hometown. I hope to honor your work with my own.

Personal thanks goes to my sister for the use of car and computer, to my fiancée, Sarah, for her manuscript and editing work, and to the rest of my family, who assisted and tolerated me as I obsessed over this awesome town's story.

The majority of the photographs that appear in this book are courtesy of the Bank of Stockton Historical Photograph Collection (BSC), the Celia Crocker Thompson Collection (CTC) of the Lodi Public Library, and the Lodi Public Library Archives (LLA), unless otherwise noted. I would also like to invite readers to visit www.LodiHistory.com for more information about Lodi's history.

INTRODUCTION

For millions of years, the land that would become Lodi lay at the bottom of a huge inland sea. The tectonic activity that formed the Sierra Nevada mountain range to the east and the Coastal ranges to the west would eventually drain this vast body of water to reveal the great San Joaquin Valley. Sediment washing from the mountains and countless years of organic material settling on the bottom of this sea would fill the valley and become the fertile soil of one of the greatest agricultural regions on planet Earth. Roughly two million years ago, the great glaciers came and melted, filling the valley with many freshwater lakes. Along with the ice came herds of wildlife, and around 12,000 years ago, humans followed.

Little is known about these early Californians, but as the centuries passed and the ice permanently retreated, they found themselves in an abundant paradise. They lived their lives for centuries sealed off from the wider world. Rivers flowed from the mountains and teemed with salmon and other fish, great herds of elk and antelope exploited the abundant vegetation and lush grass, and great groves of valley oak provided shelter and food. Eventually these early people became or were replaced by the Native American tribes of the historic period. One of these tribes, the Miwok, would live undisturbed in their Lodi area home until the first coming of the Europeans in the late 18th century.

The first Europeans to reach the valley were Spanish explorers from the missions along the coast. Gabriel Moraga was the first explorer in the vicinity. He passed south of Lodi in 1806 and named the Calaveras River. Later, in 1817, Fr. Narcisco Duran made direct contact with the Miwok of the Lodi area. He writes about meeting a war party of Muquelemnes Indians and inviting them to mission San Jose. After the Spanish, explorations were made by Jedediah Smith in 1827 and by John C. Fremont in 1844. In 1832, an unknown plague ravaged the length of the San Joaquin Valley, devastating the native population of California. Unfortunately for the Miwok, the spread of disease was not their only worry. Their world would change forever with the discovery of gold on the American River in 1848.

Prior to 1845, the only residents of the area were the itinerant trappers after the abundant wildlife along the river. This changed in 1846 when Thomas Pyle and his family settled on the Mokelumne River crossing (near present-day Tretheway Road) that Fremont had used two years earlier. Soon more settlers came, including men like Roswell Sargent, David Kettleman, and John Lehman, who realized that taming the land could provide a steady income that gold mining could not sustain. With the influx of new humanity, a settlement was established northwest of present-day Lodi. Founded by Jeremiah Woods near a river crossing he developed, it would later become Woodbridge. One year later, this settlement and the brush land that would grow into Lodi became part of the Elkhorn Township of San Joaquin County, named after the plentiful elk antlers that littered the ground.

In 1869, four area landowners, Allen Ayers, John Magley, Reuben Wardrobe, and Ezekiel Lawrence, petitioned the Central Pacific Railroad to pass the westernmost portion of the transcontinental

railroad through their land east of Woodbridge. This route was on higher ground and was not prone to the frequent flooding experienced downriver. As the tracks went down across the fertile soil, the town of Mokelumne, named after the nearby river, was officially born on August 25, 1869. The railroad proved to be a benefit, and the town boomed. Entrepreneurs flocked to the area, followed by schools, neighborhoods, and churches. Mokelumne soon outpaced Woodbridge as a favored place to settle. A fire in 1887 destroyed most of the business district and threatened the growth, but the citizens rebuilt. Farms and ranches sprang up around the town, and the agricultural muscle of the area was quickly realized.

As the town established itself, it became apparent that a new name was needed for the settlement. Confusion with the nearby communities of Mokelumne Hill and Mokelumne City hampered deliveries, delayed mail, and hindered shipments. In 1873, residents petitioned to change the name, and either Salem or Lodi was offered as a replacement. Lodi officially became the new name on March 21, 1874. Interestingly enough, it is unclear as to how such a unique name was chosen. Three different versions have been presented.

The first, and perhaps most reasonable possibility, was that the pioneer Morse and Elliott families wanted to name the town after Lodi, Illinois, where they were originally from. The second was that the town was named after a champion racehorse that impressed local sportsmen (see page 18). The third is the most dramatic and most likely reason for the name change. The railroad experienced great difficulty in building a bridge across the Mokelumne River, with its shifting soil and strong current. The difficulties reminded Robert and Richard Cope, admirers of history and members of the name selection committee, of the struggles of Napoleon and his soldiers crossing the Adda River over the bridge of Lodi, Italy, in 1796. Although obscure, this reason for the change carries the most factual weight.

At the beginning of the 20th century Lodi changed again, this time because of German settlers from Russia who came by way of the Dakotas and other Midwest states. These new Lodians would change the town from a rough-around-the-edges sporting and saloon center into a hardworking religious town. The new arrivals embraced farming and continued to build the town into prosperity. The Germans, along with significant populations of Italians, Japanese, and Hispanics, would leave their own unique mark on the area. The new arrivals were instrumental in securing the incorporation of the city in 1906. Lodi had taken the next step in its evolution.

As the city grew, so did the farms surrounding it. Agriculture became Lodi's main industry. Farmers planted wheat and then watermelons, but each farming boom came with a bust. After new methods of irrigation and fruit transportation were developed, local growers focused on grapes, and Lodi's agricultural identity was firmly established. In 1907, the risky switch to grapes was celebrated with the Tokay Carnival, the largest celebration the city had ever seen. In later years, the Grape Festival would celebrate the area's bountiful harvests.

Time marched on, and the storms came: Prohibition, the Great Depression, farm worker strikes, and both World Wars. Lodi survived them all. By the 1930s, businesses outside of agriculture, such as the Super Mold Tire Company and then General Mills located in the area and diversified the city's economy. Today Lodi is a bustling city of more than 60,000 people surrounded by vineyards, orchards, and farms of every type. Agriculture remains its vital focus, but other industries have become just as important. Lodi boasts a diverse population and an independent economy, and is still considered an excellent place to live. It is, and has always been, livable, lovable, Lodi.

One

THE COMMUNITY

NATIVES, PIONEERS, AND ENTREPRENEURS

While evidence from Lodi's prehistoric era is scarce, a mysterious people known only as the Windmiller culture lived around the delta region more than 4,000 years ago. These people were replaced at some point with an equally mysterious Hokan-speaking culture, which, in turn, was replaced by the Native Americans of the historic period. The first tribal culture to directly leave a lasting mark on the Lodi area was the Plains Miwok, who lived between the Mokelumne and Calaveras Rivers. A branch of this tribe lived in a substantial village east of Lodi. The Mokelumne tribe (*mokel* likely being a corruption of the Miwok word for river and *umne*, meaning "people of") would leave their name as a lasting legacy to the river that had given them sustenance during the centuries. Life changed drastically for the people of the river during the mission period and even more so when gold was discovered on the American River. Up to this point, northern San Joaquin County was scarcely populated by Native Americans, trappers, and a few brave homesteaders undaunted by the remoteness of the area. The influx of people eventually brought hardy settlers to the land around the river where the fertile farmland was attractive for those eager to start new lives. The next arrivals came at the beginning of the 20th century, when many ethnic Germans from Russia came via the Midwest to farm a more inviting climate. First making their way to states like Kansas or North and South Dakota, the Germans formerly living in Russia had fled the discriminating policies of Czar Nicholas I. So many families came that Lodi was soon a predominately German enclave. They changed the composition and reputation of the town from a rowdy, saloon-filled sporting center to a devout, hardworking, and conservative place. In addition to the diverse nationalities that came during the gold rush, Lodi has also been home to significant populations of Italians, Japanese, and Chinese. Today many Hispanics call Lodi home, making them and the Germans Lodi's largest ethnic groups.

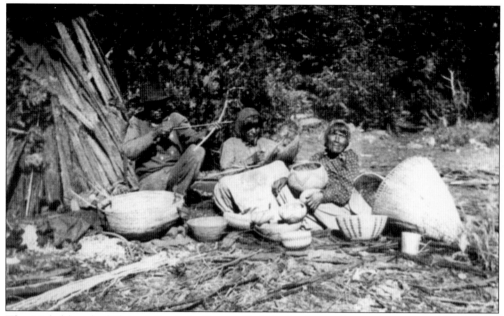

The Mokel band of Plains Miwok Indians called the Lodi area home for centuries before the arrival of Europeans. The abundant wildlife and lush vegetation of the river provided everything they needed to survive. They lived in bark and grass huts, made intricate baskets to gather acorns from valley oaks, hunted the abundant game, and fished nearby, never straying far from their beloved territory. (BSC.)

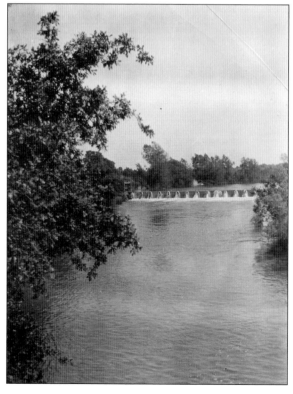

There are few reminders of the Mokel tribe; only the river's name remains to honor those people who lived here in ancient times. The Mokelumne River, seen here from the Woodbridge Dam, has always been the lifeblood of the region, first for the natives and later for the farmers who used the river water to irrigate their crops. (LLA.)

In 1870, Lodi gained one of its most eccentric and nationally famed citizens. Laura DeForce Gordon (pictured at right) was a skilled writer, lecturer, and advocate for the equal rights of women. She organized the California Women's Suffrage Society and fought for voting rights the rest of her life. Gordon also became one of the first women, along with Clara Foltz, admitted to practice law in California. In addition to her writing, lecturing, and political work, she was a practicing spiritualist and claimed the ability to talk to the dead. She divorced her husband, Charles Gordon, in 1880 when it was discovered that he skipped out on another wife and family in Scotland. Afterwards, she concentrated on her San Francisco law practice, returning to her home on Lockeford Street in Lodi (pictured below) on the weekends. (Both, BSC.)

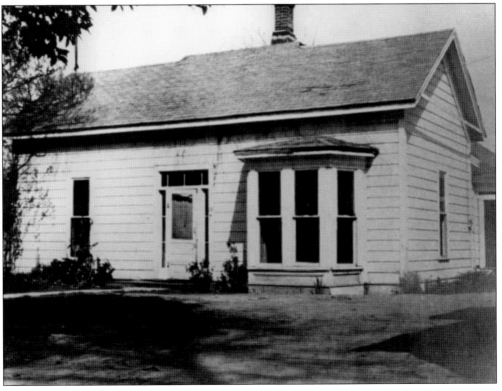

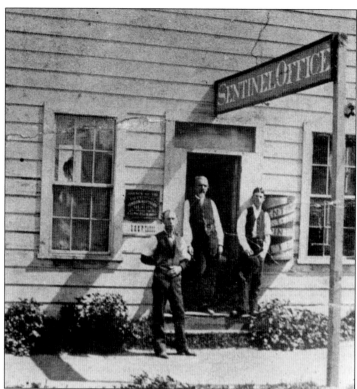

Outside of the *Lodi Sentinel* newspaper office is, from left to right, Jack McQuaid, Ralph Ellis, and Wilson Ellis. The Ellises founded the newspaper as a family business in 1881, one of several serving Lodi in the early days. The first newspaper in Lodi was the *Valley Review* and was published by a woman, Gertie DeForce Cluff (sister of Laura Gordon), who started it in 1878. (BSC.)

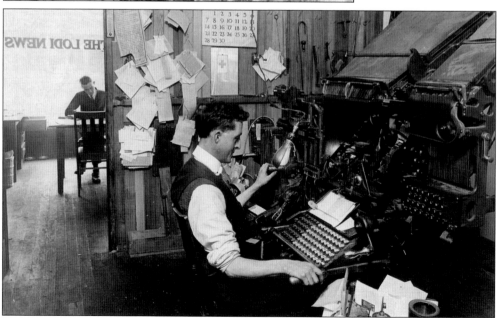

Owner Fred DeMille (right) works at the linotype machine of the *Lodi News*, while owner Delmar Rinfret does paperwork in the background in 1920. The *Lodi News* was established in 1918, and in 1935, it merged with the *Sentinel*. The *Lodi Times* also eventually merged, making the paper the longest-running business in Lodi. It operates today as the *Lodi News-Sentinel*. (San Joaquin County Historical Museum.)

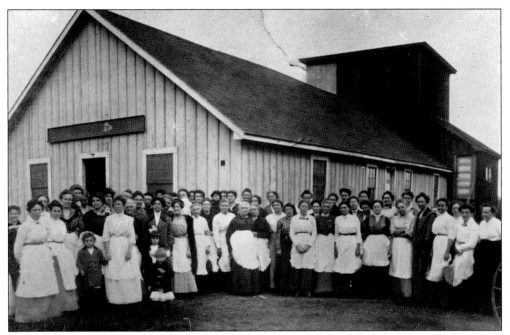

The White Apron Club was established in 1878 as an early social club for women. The members are standing in front of Lafayette Hall around 1900. The hall was an early community meeting place, west of Lodi. Members who forgot their white apron were fined 5¢ to go toward club activities. It is possibly the oldest women's organization in San Joaquin County. (BSC.)

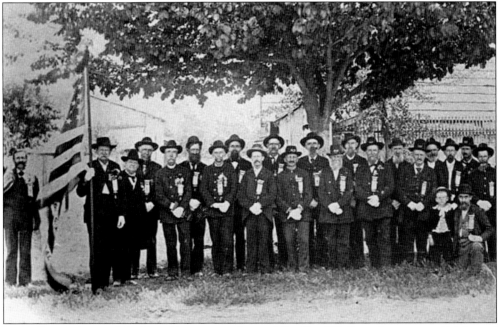

Lodi's Grand Army of the Republic poses in front of Stoddard Hall on the corner of Main and Oak Streets in 1895. The organization was made up of Union veterans of the Civil War. Edwin Spencer (left of the flag) was a local photographer and Civil War veteran who arranged for this group portrait to be taken. (BSC.)

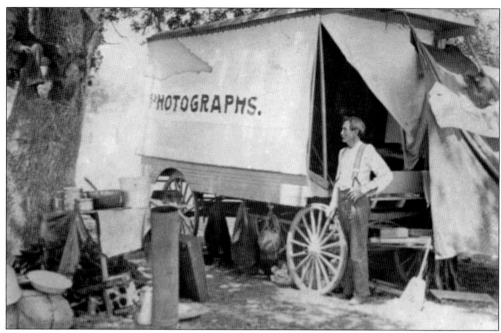

Edwin Spencer came to Lodi with his traveling photographer's wagon, seen here in the 1870s. As the first photographer in the new community, Spencer took many portraits and photographs of early Lodi (then known as Mokelumne) and its residents. In 1902, he opened a permanent studio and operated it until 1914. (BSC.)

Frank Lease owned a ranch near Victor and was called the "Klondike King" after he made his fortune in the Alaskan gold rush. After returning to California, Lease built many of the houses on Elm Street from Pleasant Avenue to Church Street. (LLA.)

Celia Crocker was born at Crocker Station near Yosemite on March 21, 1874. In 1903, she married Wilson Thompson and moved to Lodi. Both became pillars of the community and were involved in many benevolent organizations that worked for the betterment of Lodi. Crocker was an avid photographer and highly talented. A significant portion of the photographs that appear in this book were taken and conserved by her. (CTC.)

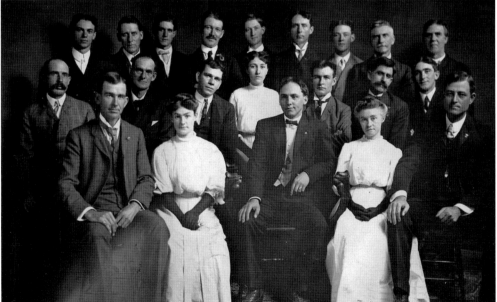

Wilson Henry Thompson (first row, left) sits with the employees of his general merchandise store in 1906. After moving to Lodi in 1896, he became one of the most successful businessmen in town and a valuable community leader. He lost his first wife, Mary Fowler, to an illness in 1900 and met his second wife, Celia Crocker, while she attended San Joaquin Valley College in Woodbridge. (CTC.)

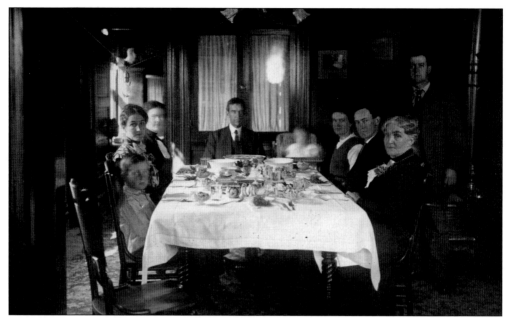

The Thompson family spends Thanksgiving at their Lodi home in 1911. Seated at the table are (first row) Allen Thompson and May Crocker; (second row) Celia Crocker Thompson and Clyde Williams; (third row) Lena Kane, Friede Williams, and Frank Kane; (head of table) Wilson Thompson and an unidentified child. Celia Crocker took pictures of everyday life, documenting them in albums she later donated to the Lodi Public Library. (CTC.)

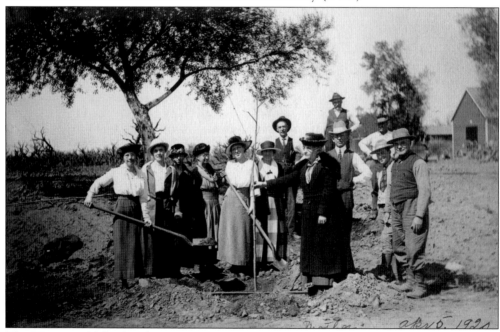

The Woman's Club of Lodi was committed to improving life in Lodi and performed many beautification projects throughout the city. Here we see the club planting the first of a series of trees on the east side of Cherokee Lane. May Crocker, mother of Celia, was heavily involved with the club and is seen here holding a sapling tree ready for planting. (CTC.)

At the dawn of the 20th century, Lodi was evolving. The sleepy town by the river was becoming a proper city. Nothing symbolized that growth more than the introduction of the automobile. Several notable men in town owned the new contraption that would eventually make travelling by horse obsolete. Here the Thompsons show off both methods outside of their home at 300 West Oak Street. Lodi families would have undoubtedly owned a horse and buggy, and, if they could afford it, an automobile. Both photographs were taken on June 6, 1905. (Both, CTC.)

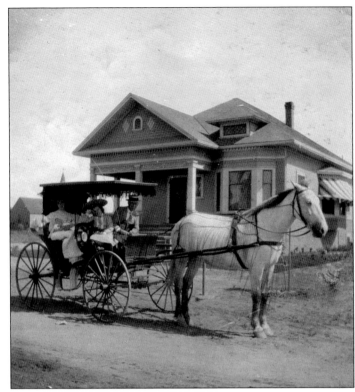

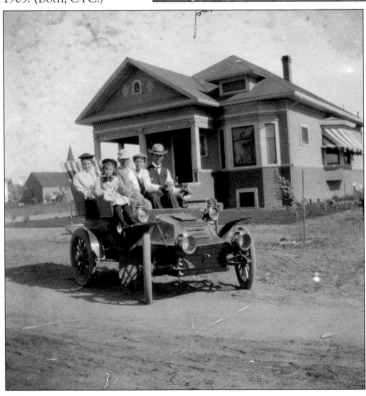

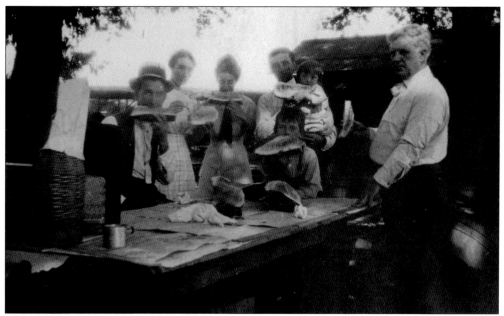

Here the Thompson and Shipman families enjoy delicious Lodi watermelons at an open air picnic. Lodi watermelons were so important to the early community that a local literary, entertainment, and social club changed its name to the Cucumis Club in their honor (*cucumis* is Latin for watermelon). The club only lasted two years, from 1896 to 1898, and the watermelon was eventually replaced with the grape. (CTC.)

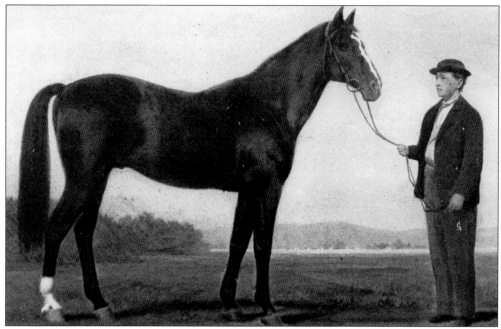

This painting of a racehorse named Lodi represents one possible inspiration for the town of Mokelumne changing its name to Lodi, although the accuracy of the story remains uncertain. The horse was a state champion in the 1860s, and several local residents reportedly watched the undefeated horse lose its first race after cracking a hoof in Sacramento. (LLA.)

On November 20, 1906, a meeting was held at the Opera House to discuss the future of Lodi. On November 27, residents voted to incorporate and become a city by a 2-1 margin. This postcard presents the five men elected as the first board of trustees, which later became the city council. George Lawrence (center) served as Lodi's first mayor. (LLA.)

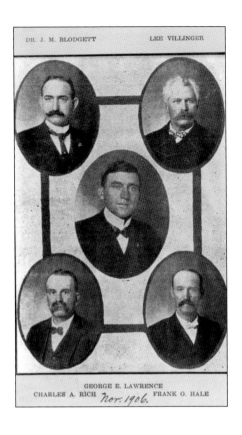

DR. J. M. BLODGETT LEE VILLINGER

GEORGE E. LAWRENCE
CHARLES A. RICH *nov. 1906.* FRANK O. HALE

Hannibal Coleman first served as the Elkhorn Township constable from 1900 to 1906 and then, after incorporation, as Lodi's first city marshall, serving from 1906 to 1920. In 1927, the city decided to uniform their lawmen, and by 1928, the city marshal officially became the chief of police, and a new era of law enforcement began with the Lodi Police Department. (LLA.)

19

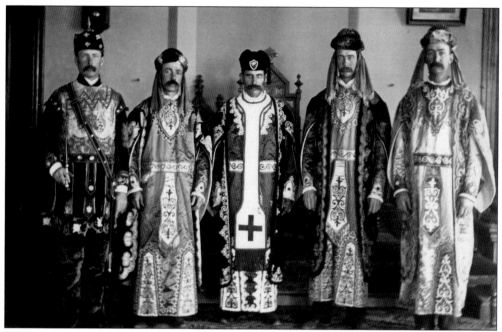

Lodi Lodge No. 41 of the Knights of Pythias, its members seen here in elaborate costumes, was organized in 1877, and many prominent citizens were members. The Knights were the first fraternal organization in the United States to receive a charter by an act of Congress. Still active today, their goals are to promote friendship and relieve suffering. (CTC.)

In 1875, Mary Lewis married George Hill, a prominent merchant and Lodi's first jeweler. Mary was active in the community and a member of several local lodges and organizations. They had two children, a daughter, Nellie, and a son, Maurice, born 17 years after his sister. Maurice was a talented musician and writer who penned an unpublished book on Lodi's history. (LLA.)

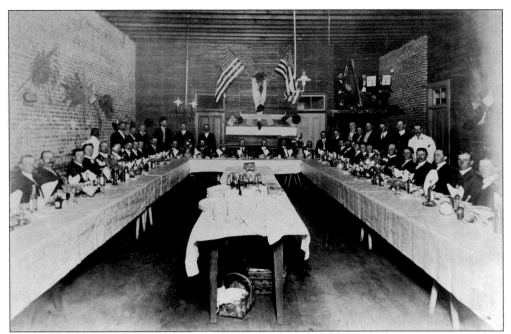

Dr. J. M. Blodgett enjoys his bachelor's banquet on the eve of his wedding, May 30, 1903. The celebration was a veritable who's who of Lodi's movers and shakers. Present at the Park Hall dinner were Charles Sollars and Samuel Axtell, who, eight years later, would shoot and kill Sollars. Blodgett was a popular dentist and served on Lodi's first board of trustees. (LLA.)

Jules Perrin came to Lodi in 1904 with his wife, Mary Cota, and his sons, seen here from left to right, David, Cecil, Paul, and Philip. Perrin and his brother Henry started the Perrin Brothers Concrete Block Manufacturing and were responsible for building local sidewalks and many concrete and brick buildings and structures throughout the area. (LLA.)

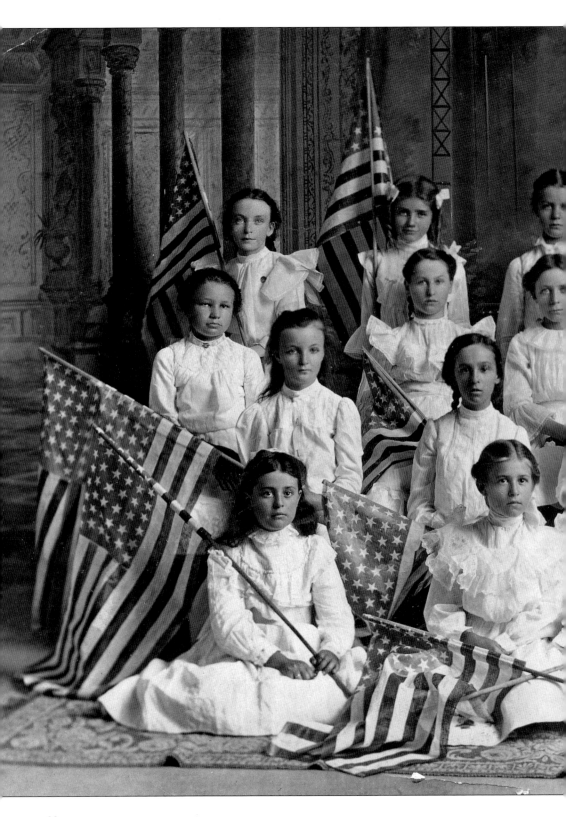

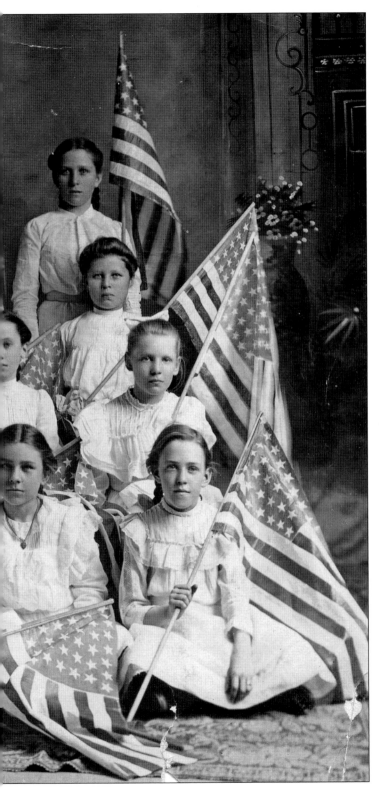

A group of Lodi girls display their patriotism in this group photograph. The girls are most likely members of an unknown civic or patriotic organization. The Fourth of July was one of the most important holidays in Lodi. It was always celebrated with a parade, picnics, and other entertainment. The flag only carries 44 stars in this photograph, dating it to sometime after 1890 and before 1896 (when Utah became the 45th state). The young ladies are, from left to right, (first row) Jennie Beronio, Julia Sturdevant, Bessie Merril, and May Bender; (second row) Sadie Pedrick, Hazel LeMoin, Geraldine Gehan, and Lottie Wallace; (third row) Amy Elam, Monie Callahan, Ruth Dunning, and Lanna Page; (fourth row) all unidentified. (LLA.)

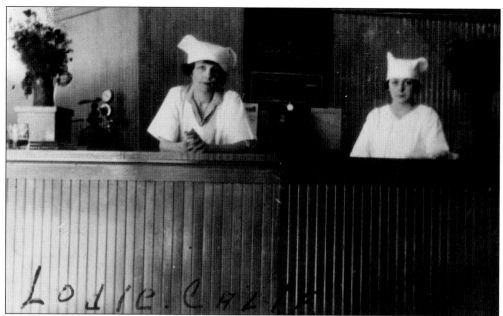

Roy Allen decided to give away samples of a new root beer formula at the World War I homecoming parade in 1919. The drink was so popular that he began selling mugs of it in his drugstore at 13 West Pine Street, seen here (notice *Lodie* is misspelled). In 1922, Allen took on an employee, Frank Wright, as a partner, and A&W Root Beer was born. (Peter Knight.)

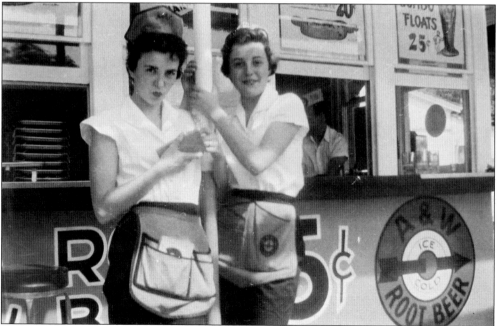

These mischievous tray-girls are ready to serve customers at the Lodi Avenue A&W Restaurant in the 1950s. In 1924, Allen bought out Wright's share of the business but kept the name, and, by 1933, had more than 170 franchised outlets serving food and root beer. Today the Lodi A&W hosts a classic car night and, in 1999, gained the record for making the world's largest root beer float. (Peter Knight.)

Two

ENTERTAINMENT
FUN IN THE LIVABLE, LOVABLE CITY

Early in its history, Lodi gained a reputation for throwing fine celebrations and festivities, which culminated in the grand Tokay Carnival of 1907. While life in early Lodi must have had its challenges, it was not without its pleasures. In addition to the many racetracks and saloons, residents enjoyed several cosmopolitan entertainments, although on a much smaller scale. Dances, socials, and concerts were staples of life in this small city, oftentimes organized and performed by the residents themselves. As the town grew and became more established, traveling minstrel shows, circuses, and theatre troupes would visit and play the halls and meeting places that were built. The earliest mention of a troupe visiting Lodi was Graham's Minstrels, who put on a show in 1874. Audiences would crowd to places like Stoddard's Hall, Larson's Hall, and Barnhart's Hall to see plays, lectures, and recitals by amateur and professional entertainers. Eventually grand venues were built to accommodate the performances; places such as Smith's Opera House and the Lodi Opera House. As early as 1908, Lodians could enjoy motion pictures, with three different nickelodeon theaters to patronize. These movie houses could serve double duty as stage venues for vaudeville and professional or high school plays, in addition to showing the latest Hollywood fare. In addition to the finer arts, the people of Lodi enjoyed athletic contests. Baseball games were always a treat at picnics and gatherings like the Los Moquelemos celebration of 1876. Since the establishment of the high school, residents have cheered local teams in a variety of sports, including basketball and football. "Lodi at that time being known as 'the sporting center' . . . has always been famed for its celebrations," wrote George Tinkham in his *History of San Joaquin County*. A wealth of early parks also served Lodi's recreational needs, including the beautiful Smith's Lake. Today Lodi boasts several recreational parks and many modern entertainments. While early residents enjoyed a dearth of theatrical choices, the impressive Hutchins Street Square facility strives to provide modern audiences with some of the same exciting entertainment that Lodi has always enjoyed.

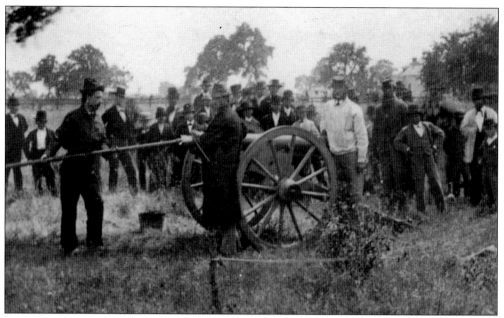

In 1854, the United States rejected the illegitimate Los Moquelemos land grant claim (which included Lodi) of Andres Pico and the claim filed by the railroad afterward. Settlers in the area were ecstatic when, in 1876, title to their land was legitimized by the U.S. Supreme Court. A grand party was held at Wardrobe's Grove to celebrate the decision, including a cannon firing by the Stockton Guard. (BSC.)

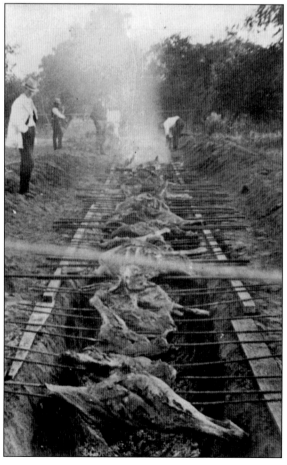

The May celebration at the grove featured music, speeches, a baseball game, and a barbeque picnic. Meat was roasted over a coal-filled trench, and ice cream was served to the thousands who showed up to celebrate. This was the largest gathering of people in the county to date. The railroad made many enemies in the community trying to claim title to land that was already homesteaded. (BSC.)

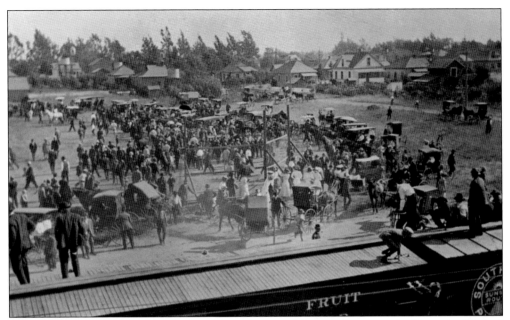

This baseball game, played at the Los Moquelemos celebration between the Yosemite Club of Stockton and Woodbridge, had to be cancelled after two innings because a number of spectators crowded the field. The final score was 11-4, with Woodbridge victorious. The game took place near present-day Hale Park. The celebration lasted for three days and concluded with a Grand Ball at the Spencer House. (BSC.)

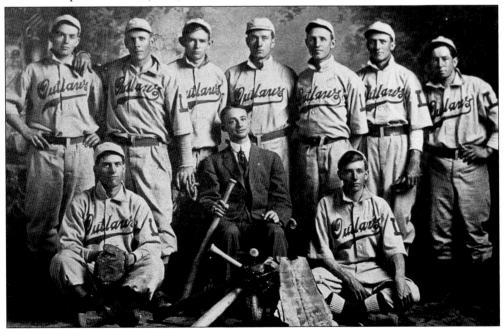

Josephus Friedberger (seated, center) owned a general merchandise store in Lodi as well as the Lodi Outlaws baseball club—the champions of the Tokay League in 1911. Affectionately known as "Friedberger's Outlaws," the team was recruited from local high school graduates and played other teams from Stockton and nearby Woodbridge. (BSC.)

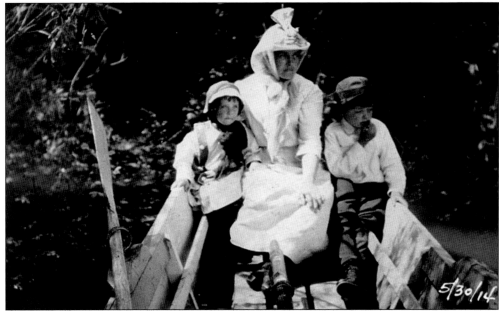

Pictured here, from left to right, are Donald, Mabel, and Robert Bird enjoying a day of boating on Smith's Lake in 1914. Originally owned by Captain McQueen and known as McQueen's Pond, the area was bought by Charles Smith in 1875 and became a lake with the construction of the Woodbridge dam in 1891. In 1934, the city bought the property from Dr. Louis Mason and turned it into a municipal park. (BSC.)

Smith's Lake, eventually known as Lodi Lake, was a popular place of outdoor recreation for Lodi's populace coming by car or horse. It was so admired that the beautiful lake was purchased in 1932 for the purpose of turning it into a resort named Loma Lake Park. Fortunately the city acquired the property for public use. Today Lodi Lake Park remains an important part of life in Lodi. (BSC.)

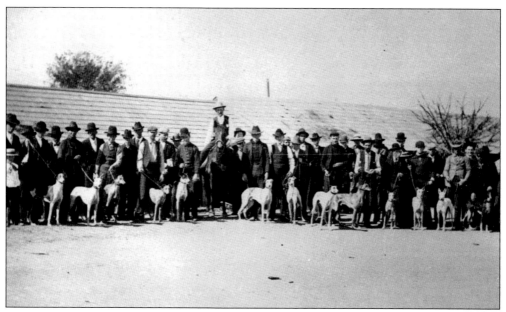

Sporting events like dog and horse racing were popular in the early days; so much so that Lodi gained the reputation as the county's sporting center, to the dismay of some residents. There were several tracks in the Lodi area, including this one in 1905 and located near present-day Cherokee Lane and Lodi Avenue. The men and their magnificent greyhounds belong to the Lodi Trotting Association. (BSC.)

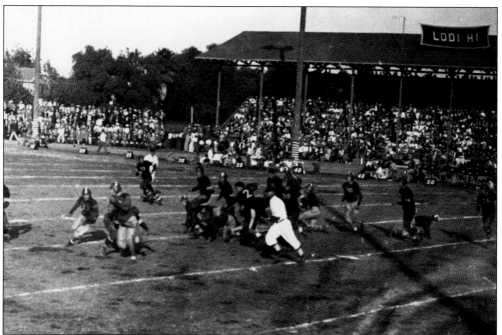

The Lodi High School football team takes on an unknown opponent in this 1935 game. The grandstands and sports field of the Lodi Union High School (present-day Hutchins Street Square) were built in 1922. High school sports games were a form of important entertainment for the community, who regularly packed the stands in support. (BSC.)

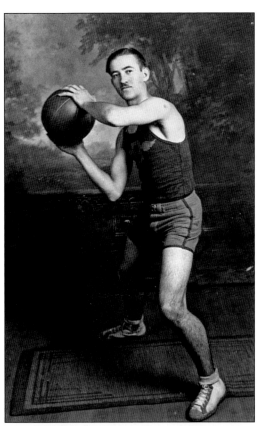

Bill Hendrix, a local sports star also known as "The Toreador," strikes a dramatic pose with his basketball in this 1928 photograph. Apparently basketball superstardom was not in the cards for the Toreador, as the 1930 city directory lists him as a sales clerk at JCPenney. (BSC.)

The Lodi High girls' basketball team of 1911 put together a spectacular undefeated season. The team members, from left to right, are (first row) Harriet Lovett and Carrie Erich; (second row) Vera Coleman, Helen Clarre, coach Belle Cooledge, team captain Hazel Lemoin (with the Lodi 'L' on jersey), and Birdie Adams. (LLA.)

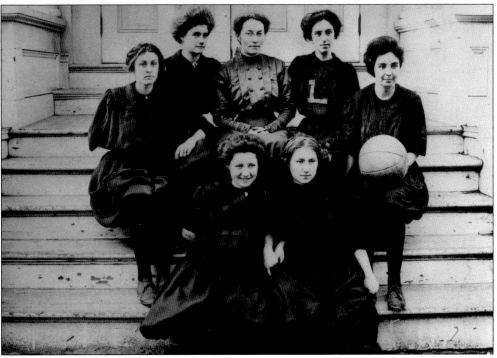

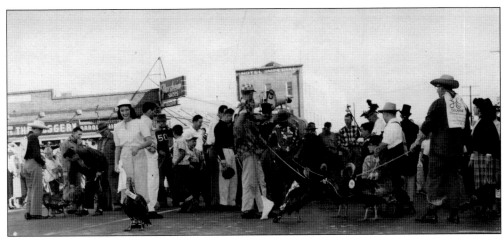

Some of Lodi's entertainments were unique, such as this turkey derby that took place near the Toggery on School and Oak Streets sometime close to Thanksgiving in the 1950s. Participants grin at the silliness as they wait with leashed turkeys for the derby to begin. (San Joaquin County Historical Museum.)

The Fourth of July was an important day to celebrate in Lodi. Here a ragtag brigade of youngsters reenact a Civil War battle. The stars and stripes fly as the brigade takes aim on the enemy. One soldier is wounded and is tended to by the girls of the Red Cross Society. A wagon pulled by a goat waits in the background to haul away the wounded. (CTC.)

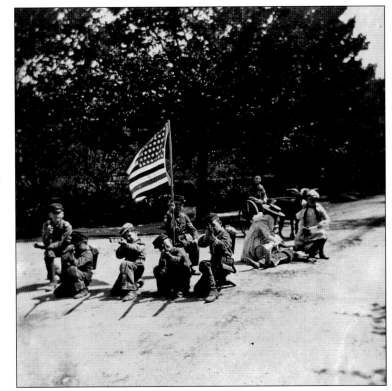

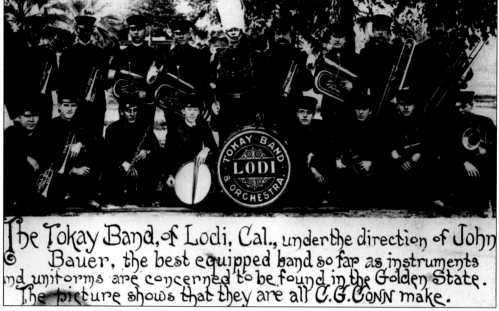

The Tokay Band, of Lodi, Cal., under the direction of John Bauer, the best equipped band so far as instruments and uniforms are concerned to be found in the Golden State. The picture shows that they are all C.G. Conn make.

This 1915 advertisement for the Tokay Band proclaims it the best dressed and equipped band in the state. It was a successful incarnation of a succession of early Lodi bands thanks to talented musical director John Bauer (right of drum major in white bearskin). The band was a staple of the local music scene for 30 years and played at many major celebrations, including the Tokay Carnival. (BSC.)

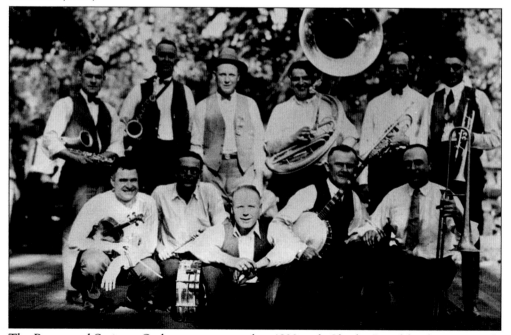

The Patton and Springer Orchestra was started in 1899 with Charles Beardsley (not pictured), Eli Springer (second row, third from left), and Bob Patton (first row, seated center). By the time this photograph was taken in 1926, the orchestra had expanded to include more instruments and players. This band was a local dance favorite and one of the most popular of the time. (BSC.)

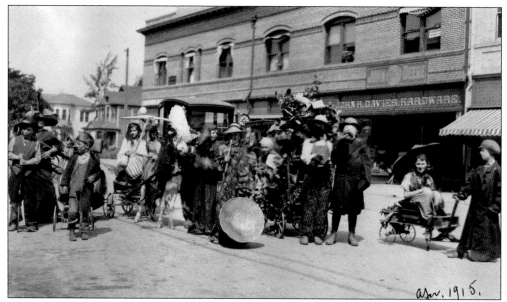

An array of creative costumes adorn the participants of this kiddie parade as it makes its way down Sacramento Street for some unknown event in April 1915. Parades were an important part of community life in a small city such as Lodi. Every major holiday was usually accompanied by a parade, in addition to other enjoyable amusements. (CTC.)

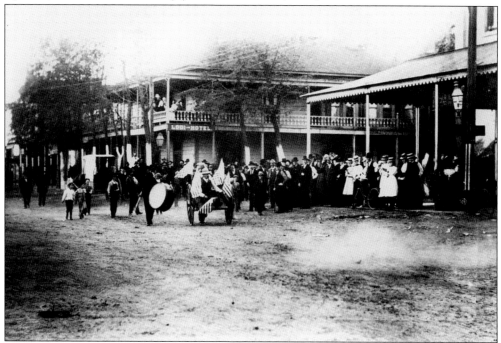

The presidential election of 1884 was hotly contested between Grover Cleveland and James Blaine. Local businessmen L. Green made a friendly bet with Alois Lutz that Blaine would win the presidency. After he lost, Green brought a 200-pound bag of flour in a wheelbarrow to the Lodi Hotel and then gave Lutz a joyride, much to the delight of townsfolk who turned out for the spectacle. (BSC.)

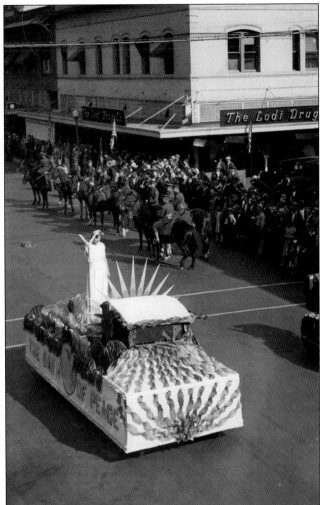

On June 4, 1919, the city held a Welcome Home Jubilee for its returning soldiers from World War I. Several mounted soldiers pause in front of the Lodi Drugstore as Mrs. Marshall rides on a float entitled "The Dawn of Peace." The jubilee was a huge affair for the city, perhaps the largest celebration since the Tokay Carnival 12 years earlier. (LLA.)

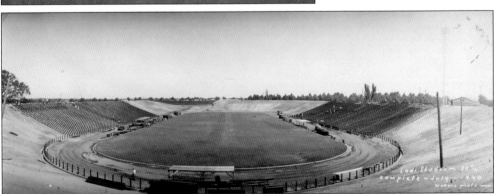

The Lodi Stadium was started in 1935 as a Works Progress Administration (WPA) project and opened on September 20, 1940. It was built at a cost of $150,000 on a horse racing track owned by Ezekiel Lawrence. Renamed Pioneer Park, its nickname of the "Grape Bowl" would stick. Both Lodi and Tokay High School still use the stadium for their sports programs and for graduations. (LLA.)

John Dougherty served as grand marshal of the Fourth of July parade in 1912. Dougherty owned the Fashion Livery Stable, the Fashion Saloon, and the Lodi Hotel. Dougherty is also credited with founding the nearby town of Terminous. One of Lodi's most colorful pioneers, he passed away five years after this photograph was taken. (LLA.)

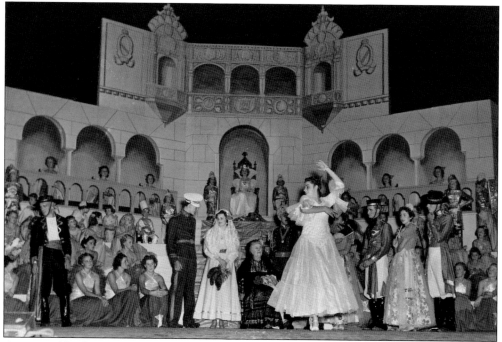

A group of finely costumed entertainers performs before festival royalty on a stage at the Grape Festival grounds in 1946. On the throne in the background is Grape Festival queen Janie Miller, and her six attendants are positioned in the backdrop's arches. (LLA.)

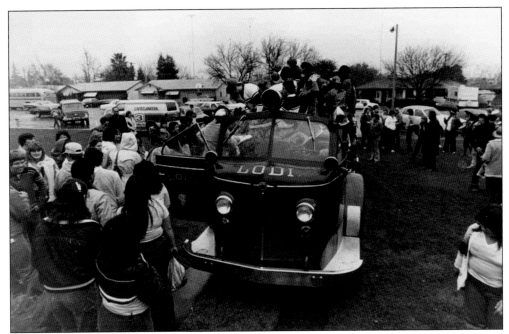

This fire truck won in a fund-raising drive for rebuilding the burned-out high school east campus into the new Hutchins Street Square community center in 1982. The 1949 American LaFrance truck, called Ruby, served as a mascot to Lodi High School's sports teams, known as the Flames. (BSC.)

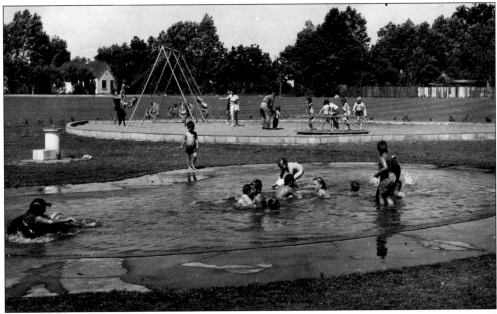

The wading pool at Blakely Park was a popular pastime for area children. It was estimated that 50 to 60 boys and girls used these facilities each day during the summer. Lodi's first park was the Southern Pacific Railroad reservation, established through the efforts of the Women's Improvement Club. In 1916, the city built a large swimming pool in Wardrobe's Grove, which would later become Hale Park. (LLA.)

Three

THE FAMOUS ARCH
PROUD SYMBOL OF A CITY

If grapes are the pride of Lodi, then the arch is its iconic symbol. The monument is the most recognized piece of architecture in the city, and its unique design inspires many residents, both old and new. The arch was designed in the mission revival–style by Stockton architect E. B. Brown and served as a centerpiece for the 1907 Tokay Carnival, as well as an official entrance to the newly incorporated city's business district. Brown's plans for the arch so impressed the city fathers that they decided to make it a permanent feature of the city. The arch was reportedly built out of wood, metal lathe, and cement by Lodi builders Edward and Fred Cary for a cost of about $500. By 1910, the city had added its name, complete with electric lights, to the icon. But the most enduring addition came in 1909, when the Lodi Parlor of the Native Sons of the Golden West stole a large papier-mache bear from an Admission Day parade float designed by the neighboring Stockton Parlor of Native Sons. The bear was placed on top of the arch facing toward Stockton as a practical joke and has been a much-loved addition ever since. By 1955, the arch was neglected and had fallen into disrepair. The Lodi City Council declared it a safety hazard and threatened to demolish the monument. Thankfully the arch was saved by the very group it had come to symbolize, Lodi's citizens. In 1981, the arch was added to the register of California Historical Landmarks as No. 931. Today the Lodi Arch is one of only three mission-style arches left in the state. The arch stands today, virtually unchanged, as a link to the town's beginnings and a proud symbol of the city. As George Tinkham put it in his *History of San Joaquin County*, "They erected the Tokay arch, over spanning the Pine Street junction of Sacramento. It is of purely mission style of architecture . . . and is today one of the most attractive features of the city."

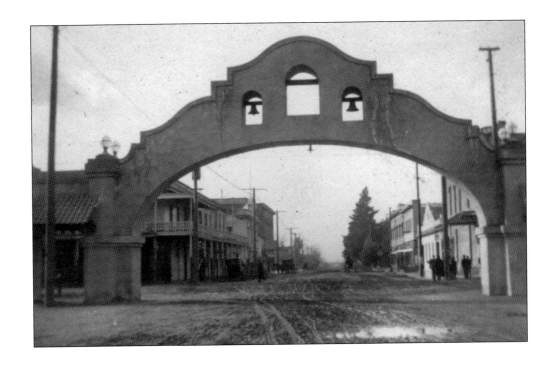

In these *c.* 1908 photographs, the newly constructed arch spans a muddy and empty Pine Street looking west (pictured above). The mission revival style that architect E. B. Brown chose recalled California's romanticized mission period, which was popular at the beginning of the 20th century. The bell is missing from the center archway, perhaps because an alarm bell was added to the structure in 1908. The bell would ring to warn the city against the ever-present threat of fire. The addition of the alarm bell lent function as well as form to the icon of the city. (Above, CTC; below, Steve Mann Collection.)

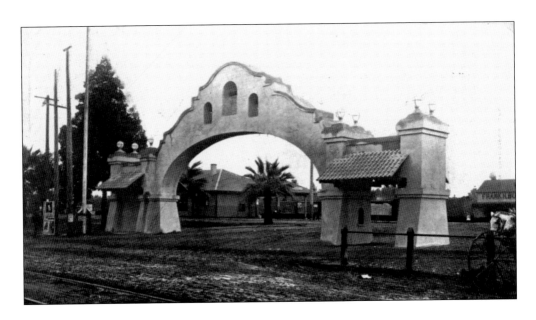

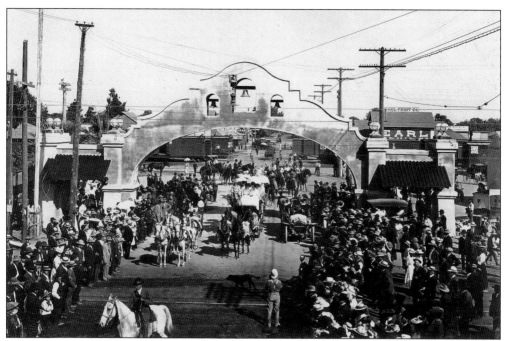

The arch's original purpose was to serve as a grand entrance for the crowds gathering for the Tokay Carnival in 1907. Lodi became the Tokay City, and the arch was dubbed the Tokay Arch. Here the carnival parade enters into the magical city. A sister arch, known as the fun arch, was built directly across from the arch pictured but was torn down after the carnival. (BSC.)

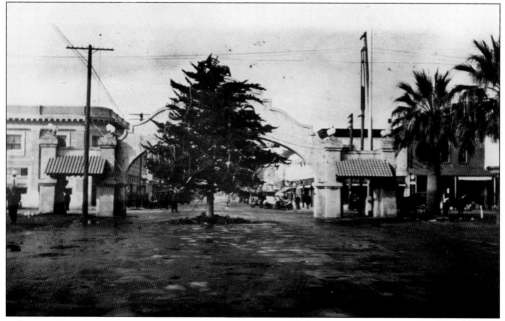

A large, decorated Christmas tree is planted in the middle of a muddy Pine Street in 1915. The arch was often decorated for the holidays, namely Christmas and the Fourth of July, when it would be adorned with patriotic red, white, and blue bunting. The arch served as the perfect place to display the town's holiday spirit. (BSC.)

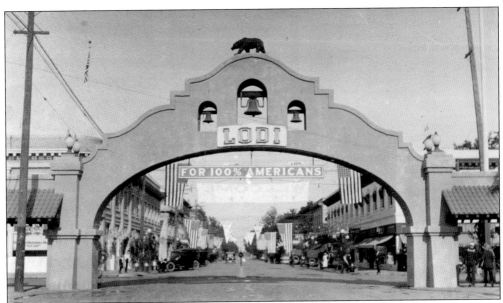

At the start of World War I, the large German population of the town was concerned that their loyalty to the American cause might be questioned. So, in May 1918, a 20-foot lit sign reading, "For 100% Americans" was installed on the arch. The high school was the first school in California to drop the study of German in favor of Spanish, and several German businesses changed their names. (CTC.)

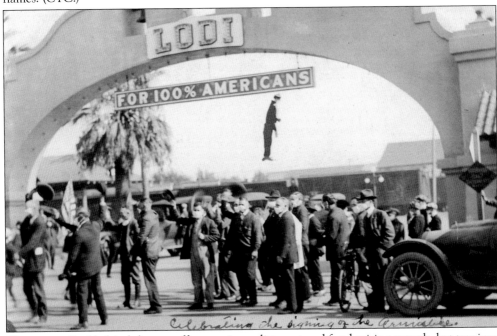

The town rallied behind the war effort, setting enlistment and fund-raising records, but tensions remained high. A prominent community member was hung in effigy from the arch in November 1917 for failing to support the war drive. Another effigy, of the German Kaiser (seen here), was hung in 1918 when Germany signed the Armistice. Men wear masks to guard against the Spanish influenza epidemic raging at the time. (CTC.)

A biplane from Mather Field performs aerial stunts over the heads of spectators leading a homecoming parade for the veterans of World War I in June 1919. Lodi paid a heavy price in the conflict, losing 27 young men. The city pulled out all the stops for this celebration, which ended the tensions the town suffered during wartime. (San Joaquin County Historical Museum.)

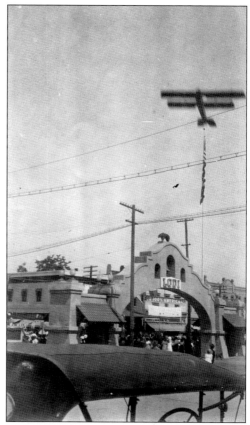

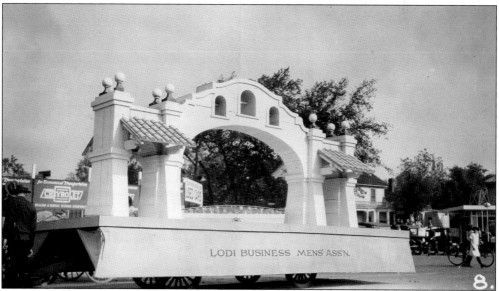

The arch has always been a symbol of community pride to Lodians, as evidenced by the Lodi Businessmen Association's entry for the Independence Day parade in 1924. The float replica would have traveled under the full-sized arch during the parade. The arch appears as an emblem and logo for businesses and organizations all over Lodi and is a truly universal city icon. (CTC.)

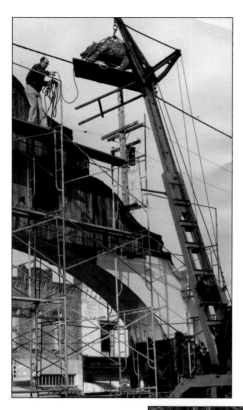

By 1955, the arch had seen better days and was in need of repair. The Save the Arch campaign was started by a group of concerned citizens after the city council refused any money to repair the monument and threatened to demolish it. Eventually the campaign raised enough funds, and renovations were carried out by Herbert (on scaffolding) and Leon Hieb. (San Joaquin County Historical Museum.)

During the repairs, the bear (being lowered off the arch) was turned around to face north toward the state capital. Independent-minded residents have long thought that the bear's original orientation, with its rear end effectively "mooning" Sacramento is a more accurate representation of the city's attitude toward state government. (San Joaquin County Historical Museum.)

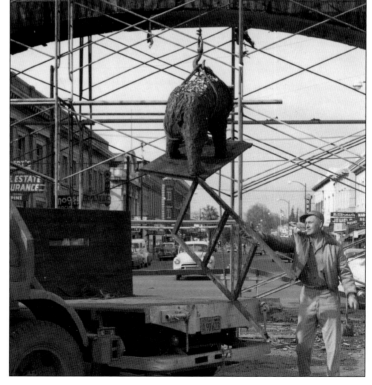

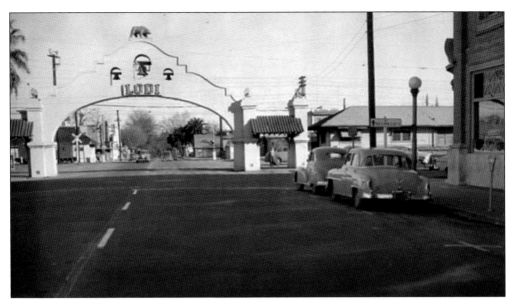

In 1961, the arch received a fresh coat of paint courtesy of the fire department and junior chamber of commerce. The color of the second bear (the first was replaced in 1934) was changed from gold to brown. In 2001, the bear was returned to its original golden color. (BSC.)

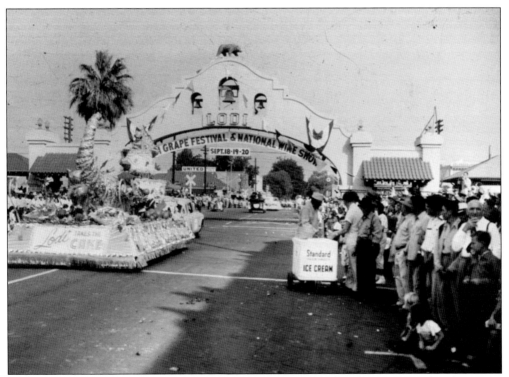

In 1981, the arch was designated as California Historical Landmark No. 931, and a plaque was added to the monument. The American Institute of Architects also honored the arch as one of only three mission arches left in California. Lodi has always understood the importance of the arch, using it as a centerpiece for its parades and festivals. (BSC.)

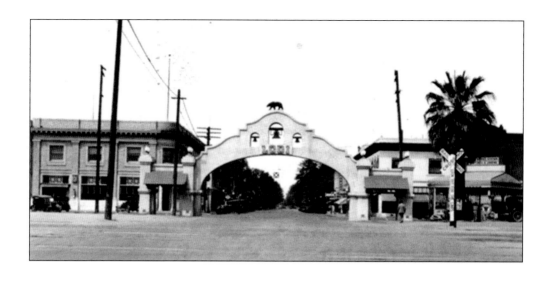

The arch has changed little in its 102 years of existence. It provides a tangible link to the past and a reminder of the town's beginning. These two photographs are both taken looking west down Pine Street. The first is from the 1920s (pictured above), and the other was taken in early 2009. The arch remains almost frozen in time while the city has continued to grow and change around it. The bear now faces north instead of south, and a parking garage has been added north of the arch. (Above, Steve Mann Collection; below, the author's collection.)

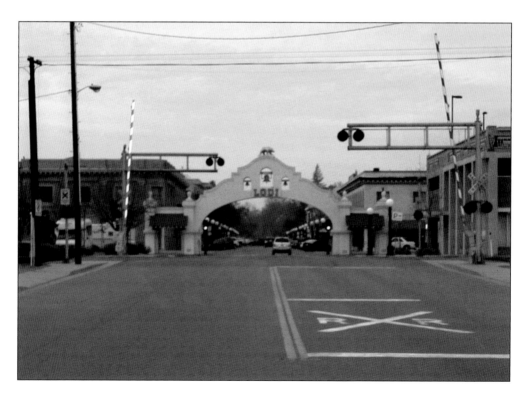

Four

AGRICULTURE
FROM WATERMELONS TO VINES AND WINES

The story of cultivating Lodi's soil begins with the first pioneers, who planted crops for their own use or to trade with neighbors. These entrepreneurial men and women soon realized that California's meager infrastructure provided a great opportunity for landowners and farmers to make a decent living supplying the throngs of people arriving to search for gold. As gold mining faded from the landscape as the state industry, commercial agriculture was there to take its place. Lodi and San Joaquin County were perfectly poised to seize upon that change. Surprisingly, the first crop raised commercially in the area was wheat. Pioneering families raised the staple crop, which did remarkably well in the rich soil with its long, dry summers. The county soon became California's wheat belt. However, the massive grain production and prosperity could not be maintained. Soon the large swaths of grain needed to be replaced with something more profitable. Lodi's next big farming venture would be the watermelon. Watermelons proved to be even more successful with the high water table lending a natural advantage to area growers. Once again Lodi excelled in its production and dominated the market until the beginning of the 20th century. Other melon-producing areas began to mark their melons with the Lodi label, and another promising market plunged. It would take a third and final switch for Lodi to find its agricultural niche. Grapes proved to be the magic bullet for local farmers. The dry climate was conquered with irrigation, and vineyards sprouted where fields of wheat once stood. Early on, table grapes were the dominant variety, which helped the area survive Prohibition, but recently wine grapes became the area's calling card. The Lodi appellation (wine region) was established in 1986, and today Lodi boasts more than 60 wineries of all shapes and sizes, and maintains a healthy diversity of crop production.

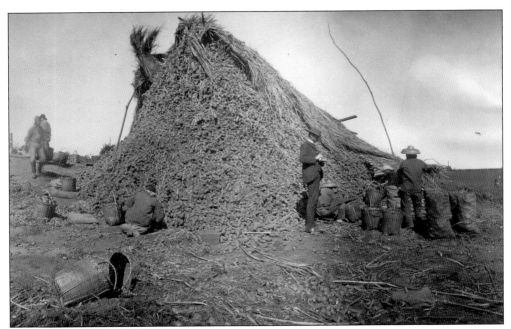

Wilson Thompson records the basket count of a small mountain of harvested potatoes grown in the area west of Lodi. Surprisingly enough, potatoes were planted as early as 1852 by farmers in the area. Even though 42 tons of potatoes were harvested in the county that year, the crop was considered a failure in the soil around Lodi because the potatoes were too small. (CTC.)

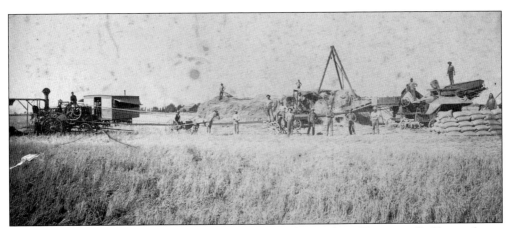

The first successful commercial crop planted around Lodi was wheat. Farmers pulled horse-drawn grain harvesters through their fields and then used steam-powered threshers to separate the grain. The climate and soil conditions around the river were ideal for growing grain, and the yields were better than those in the Midwest. By 1880, San Joaquin County was producing the largest wheat crop in the world. (CTC.)

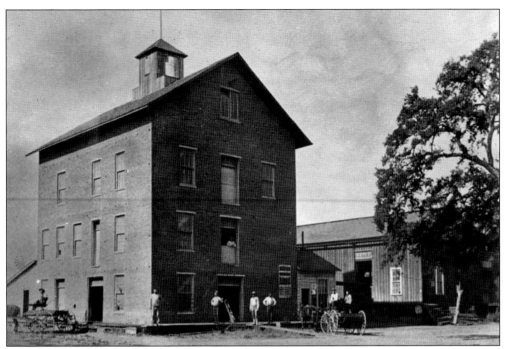

With the success of wheat and barley, mills were soon needed to process the large amounts of grain cultivated on Lodi farms. The Lodi Flouring Mill was built in 1876 on the corner of Main and Locust Streets to handle the load. This mill could produce 200 barrels of high-quality Lodi flour every day. The area's flour even won first prize at the 1867 Paris World's Fair. (BSC.)

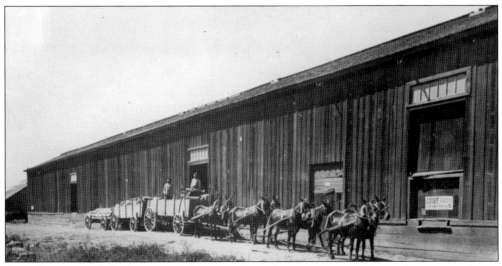

A tandem wagon full of grain pulled by an eight-mule team arrives at Corson's grain warehouse on Main and Locust Streets. Charles Corson also operated a skating rink at the same location. The warehouse was destroyed by fire in the 1890s. The Earl Fruit Company later occupied the location. (BSC.)

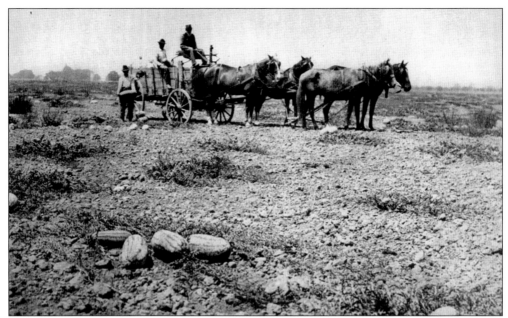

When the grain market began to falter in the late 1880s, Lodi farmers searched for a new and more marketable crop. The answer came in the form of watermelons. As it had been with wheat, the water table was so high that irrigation was not needed, and the languid, dry summers produced an excellent crop. The wheat fields south of Lodi were soon replaced with promising watermelon patches. (BSC.)

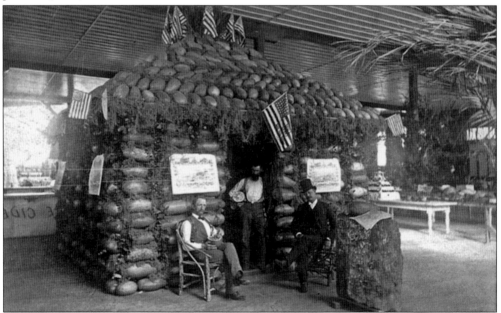

Three unidentified men sit in front of a watermelon house displayed at the San Joaquin County Fair in September 1887. The house was decorated with lithographs of Lodi and was built from watermelons grown by the Live Oak Colony. Lodi held the title of "Watermelon Capital of the World" until the beginning of the 20th century, when prices fell once again, and farmers were eager to farm something more profitable. (BSC.)

After wheat and watermelons failed, farmers searched for a crop that would provide a lasting return. Grapes had always done well in the sandy loam around Lodi, so farmers began to plant different varieties, in search of a perfect match. The Flame Tokay grape proved to be the most promising. Vineyards began sprouting up all over Lodi like these at the Fowler Barns in 1907. (CTC.)

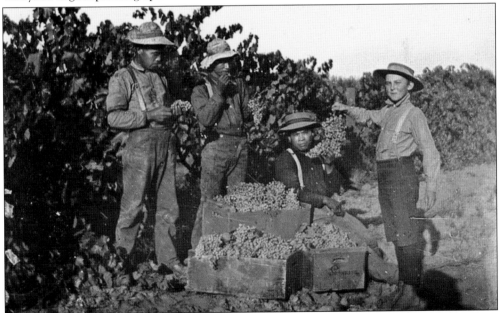

Tokay grapes required more irrigation than previous crops, so growers installed windmill pumps and used the river. Harvesting techniques required hand picking, as seen in this rare photograph of migrant workers in the Doering vineyard. The Tokay grape ripened to a deep and delicious red color that other areas could not produce, and they could be eaten as a table grape or crushed into wine. (BSC.)

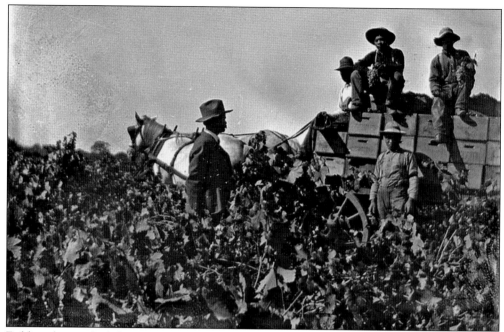

Field workers picked the grapes by hand and put them into field boxes (in another scene at the Doering vineyard) to be taken to one of the packing sheds in Lodi. Long lines of wagons would wait outside of sheds at the height of harvest season. At the sheds, the grapes would be separated and readied for shipment to eastern markets. (BSC.)

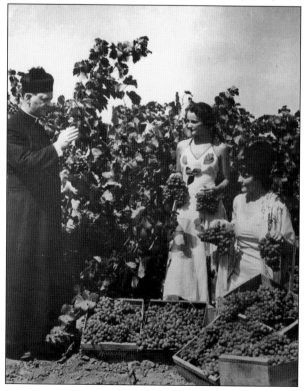

Fr. Charles Hardeman of St. Anne's Catholic Church in Lodi blesses the grapes before the 1937 Lodi Grape Festival. Agriculture is a risky venture, and the blessing of the grapes is an important part of the harvest time celebrations in the fall. Seen with Father Hardeman are Jackie Ritchie (left) and Laura Ortez. (BSC.)

Grapevines receive an important watering at William Micke's vineyard, south of Lodi. Reportedly the Tokay variety of grape originally came from the rugged Kabylia province of Algeria in northern Africa, although other references to Hungarian Tokaji grapes are intriguing. The grape contains seeds, and eventually the Tokay table grape lost popularity to the seedless varieties. (BSC.)

Although grapes are undoubtedly king, Lodi's fertile soil is home to many diverse crops, evidenced here by an unidentified man in a field of seed carrots in 1962. Cherries, walnuts, and a host of other produce are grown around Lodi and within the county. The greater San Joaquin Valley has long been one of the greatest food-producing regions in the world. (BSC.)

Irrigation needs increased with the new crop to combat the long, dry summers, and a steady water supply was needed. Byron De La Beckwith claimed water from the Mokelumne River and formed the Woodbridge Canal and Irrigation Company. De La Beckwith and his partners began construction on a dam and 24 miles of canals, which was completed in 1891. By 1898, the company was in foreclosure. (BSC.)

Employees of the E. G. Williams and Sons packing shed take a break to pose for this photograph in 1907. Men and women could work in the packing sheds, although it was tough and tedious work. No doubt humorous stunts like the man on the left wearing a bonnet and apron helped to relieve the stress of the day's toil. (BSC.)

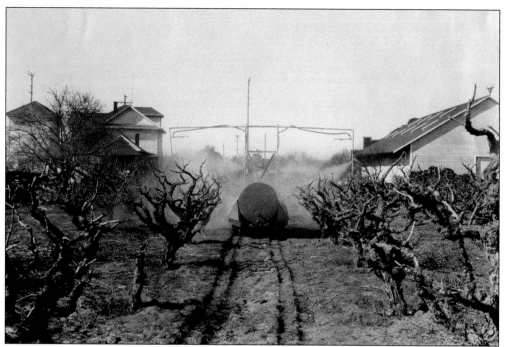

Pest control and eradication are important parts of agricultural enterprise. In the early days, farmers were completely at the mercy of insects and disease. At one time it was erroneously believed that crop diseases and pests, including phylloxera (a small aphid-like insect that feeds on the roots of grapevines) could not flourish in California's mild climate. Today popular methods of pest control are spraying from a tractor (pictured above) or crop dusting with an airplane (shown below). Here the Precessi Brothers crop dusting service makes a low pass over a vineyard around 1950. (Above, San Joaquin County Historical Museum; below, BSC.)

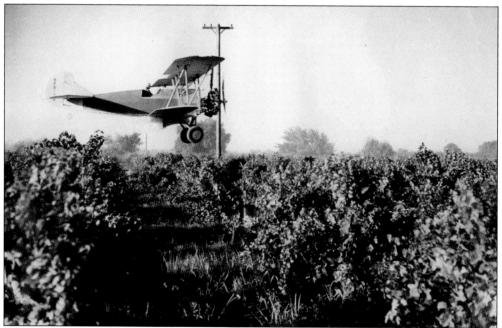

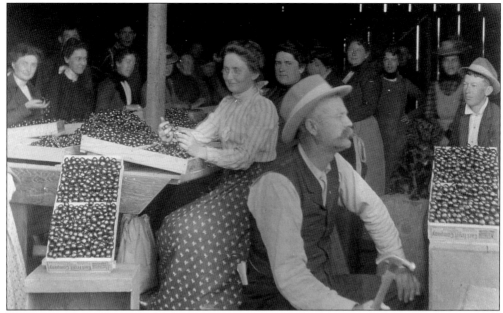

The J. A. Anderson packing shed was established in 1902. Anderson is the gentleman wearing the hat (front center). The packing shed was one of the first to ship Lodi fruit, including the cherries shown here. In 1894, Anderson and Charles Rich gathered a group of growers together to fill a railroad car full of fruit and thereby receive a lower shipping rate. Anderson also managed the Earl Fruit Company, another early fruit packer and shipper in town. (CTC.)

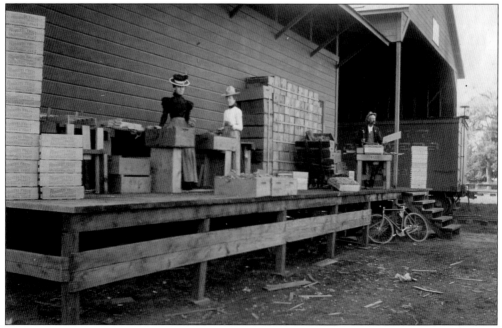

Finely dressed ladies stand among boxes of grapes and cherries on the loading platform of the Anderson packing shed. J. A. Anderson once again wields his trusty hammer in the background. Wagons would pull up to the platform and off-load their cargo for packing, and then the boxed fruit would be loaded onto the waiting railroad car seen here parked under the shed. (CTC.)

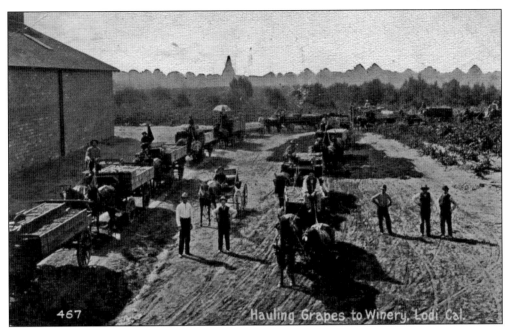

In this 1905 postcard, a line of farm wagons await off-loading at the Community Winery, later to become Allied Grape Growers, located at Sacramento Street and Woodbridge Road (present-day Turner Road). Sometimes these processions were a day-long affair. (CTC.)

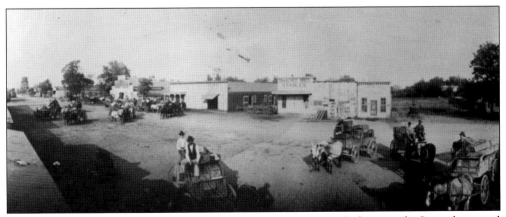

Wagons make their way to off-load into railcars in this rare 1895 photograph. Several original buildings can be seen on Main Street looking north, including Crabtree Stables, the Wellington Steacy Smithy and Wagon Shop, and the Siegalkoff Stables. The Carey Brothers water tank can be seen to the far left, where later a jail and a city hall would be built. (BSC.)

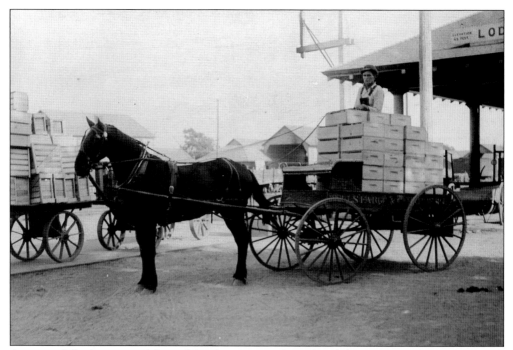

A wagon full of grapes is delivered for shipment to the railroad depot in 1912 by Archie Boyd. Notice that the wagon carries the label of Wells Fargo and Company Express and is most likely a former supply wagon of the famous company refurbished for use on the farm. (LLA.)

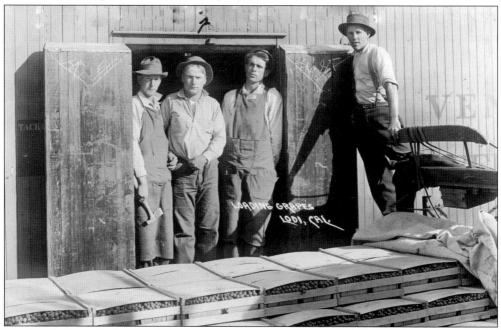

The Pacific Fruit Exchange of Sacramento was managed in 1910 by local businessman Wilson Thompson. The company operated four sheds and a packing outfit on Main Street, south of Lodi Avenue. The man in the center of the doorway is identified as Howard Gillispie, an important person at the exchange. (CTC.)

An unidentified woman inspects a lug box full of grapes in this famous photograph by Stockton photographer J. Pitcher Spooner. Spooner recorded several scenes of the E. G. Williams and Sons packing shed that was adjacent to a vineyard owned by his wife's family. His photographic series was displayed at the 1907 Tokay Carnival. (BSC.)

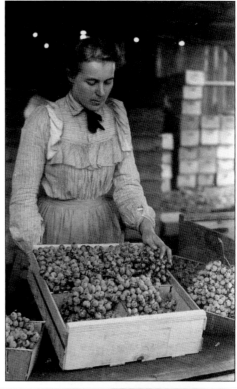

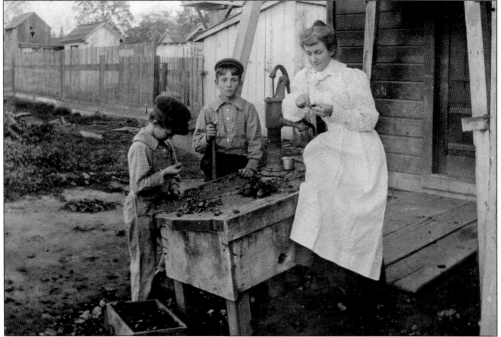

Shells litter the ground as Charley and Douglas Newborn, and their mother, Mrs. Charles Newborn, engage in the tedious work of hand shelling walnuts in their backyard north of Lodi. In addition to grapes, walnuts and other nut trees are important to the area's agricultural diversity. (LLA.)

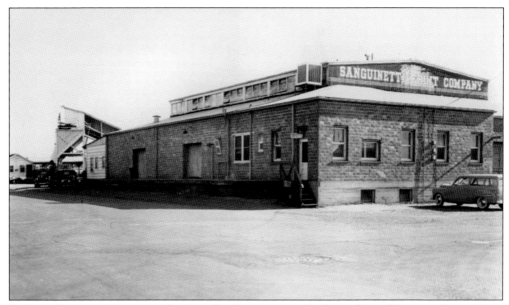

In the early years of grape production, the fruit was mainly shipped as table grapes from places like the Sanguinetti Fruit Company, seen here around 1955. Grapes grown for crushing into wine would come into their own much later as wineries became established in the area. (BSC.)

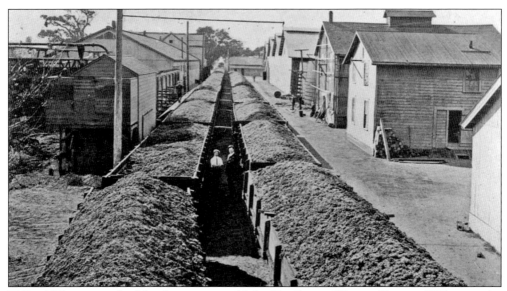

El Pinal Winery, north of Stockton, was established by George West and his son William as the county's first commercial winery in 1858. Its distilleries were California's largest and could handle more than 5,000 tons of grapes annually. The Wests were the only area wine-grape buyers, and Lodi growers were forced to accept extremely low prices until a winery cooperative was established by the Woodbridge Vineyard Association in 1904. (BSC.)

Brothers Robert (left) and Peter (right) Mondavi pose with their father, Cesare (center), in front of their home. The Mondavi family came to Lodi and entered the grape industry first as shippers and then as winery owners. In 1943, Robert convinced his parents to purchase the Charles Krug Winery in Napa, which began the association of the Mondavi name with the California wine industry. (Woodbridge by Robert Mondavi.)

After immersing himself in all aspects of the wine industry, Robert Mondavi became a pioneer and innovator, employing unique growing techniques and state-of-the-art technology. He was instrumental in garnering international attention for California-produced wine. In 1979, he purchased a cooperative winery north of Lodi and expanded and renamed it the Woodbridge Winery. Today Woodridge by Robert Mondavi continues its mission of putting quality California wines on every table. (Author's collection.)

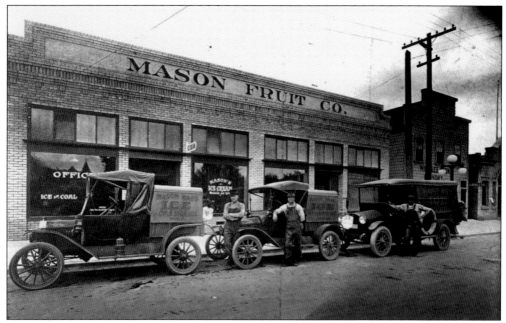

The Mason Fruit Company was founded by Dr. Wilton Mason and his brothers Herschel and Lewis at 214 North Sacramento Street. It packed and shipped fruit in ice made at its own factory. The trucks out front were used for the home delivery of ice and coal. An ice cream parlor was also located within the building, making this a popular Lodi business on hot summer days. (BSC.)

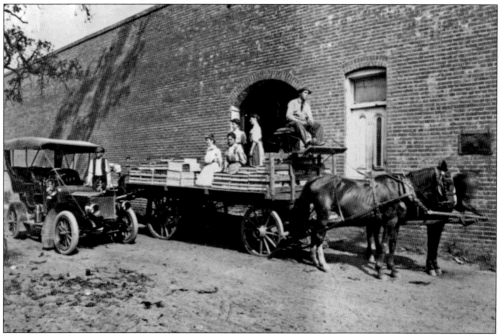

Perry Clark drives a wagon loaded with grapes from Crescent Vineyards outside of the Mason Fruit Packing building. Hitching a ride on the wagon are, from left to right, Louise Deumenther, Mamie Milloglave, Mabel Froehnert, and Annie McKinzie. Lewis Mason stands next to his automobile. (BSC.)

Cooperative wineries were established in the beginning to help give growers more control and to combat monopolies such as the one El Pinal Winery had created in the early 1900s. The Wine Growers Guild, later to be known as Guild Winery, was just such a group, and by the 1960s, it was the largest wine cooperative in the world. (BSC.)

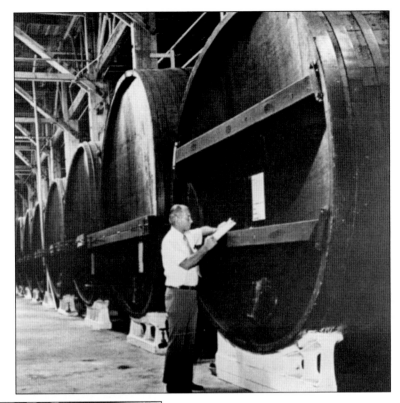

As the wine aged in its barrels, the 1940s and 1950s saw a rise in Lodi's wine grape production. Official recognition came in 1956 when the government declared Lodi a wine-grape growing district. Wineries began using Lodi's Tokays in port, sherry, and for blends in other wines. Soon the region earned the nickname of "America's Sherryland." (BSC.)

William Micke came to California from Missouri in 1897 intending to settle in Sacramento. But it would be in the fertile Lodi soil where he would make his mark. Micke and partner John Merrill began by raising peaches and apricots on the former racetrack of the Lodi Trotting Park. Micke later planted Tokay grapes and established a fruit shipping and packing business near his home on Cherokee Lane. Micke and his wife, Julia Harrison's, most lasting legacy came in the form of an oak tree grove they donated to the county for use as a park (see page 121). (San Joaquin County Historical Museum.)

In 1918, the Roma Winery was constructed on 320 acres along Victor Road east of the Central Traction Line. Despite the looming threat of Prohibition, the winery grew to be one of the largest in the world by the 1930s and 1940s. After the repeal of Prohibition in 1933, it added a large bottling room. (Steve Mann Collection.)

The ability to bottle its own product became increasingly important for area wineries. In 1946, the Guild Winery announced plans to construct a bottling plant with a capacity of two million gallons. Some of the finished product is seen here in a storage facility at the guild. (BSC.)

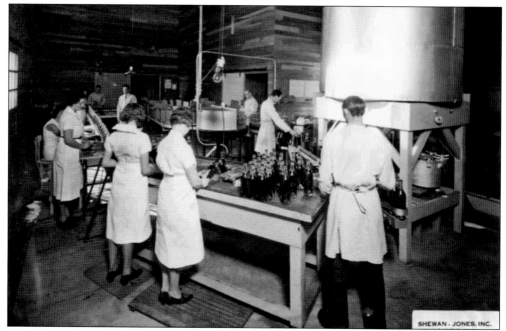

The Shewan-Jones Winery distilled brandy, vermouth, and a host of other products in its facility located between Sacramento and Stockton Streets, south of Turner Road. It became a nationally known wine and brandy industry pioneer, winning more awards than any other winery since Prohibition. (BSC.)

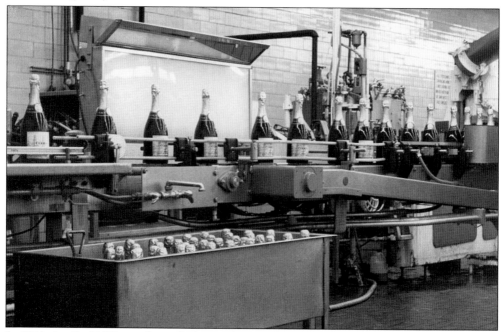

In 1964, the Guild Winery diversified it products and began to bottle champagne. By the 1980s, when this photograph was taken, the guild was the largest winery in the Lodi area. Agricultural cooperatives like the guild, where farmers control production, processing, and the marketing of product, can prove to be beneficial, but the Lodi cooperatives were largely unsuccessful. (BSC.)

Five

CELEBRATING THE HARVEST
FROM TOKAY CARNIVAL TO GRAPE FESTIVAL

Shortly after Lodi's incorporation in 1906, civic leaders were eager to spread the word about Lodi's rich soil and the crops it could produce. A brainstorm by local businessman Charles Ray, to hold a carnival in honor of the Tokay grape—Lodi's most important crop at that time—was quickly seized upon as a perfect way to promote the new city's industry, growth, and prosperity. In George Tinkham's *History of San Joaquin County*, it was celebrated thus: "To show and to advertise to the world the beauty and the value of the flaming Tokay grape, so named because of its beautiful coloring when ripe, like a dark red flame of fire. It grows to perfection in no other section of the land." The community wholeheartedly embraced the idea, and by June 1907, the funds were raised, and advertisements and postcards were distributed all the way to San Francisco for the three-day event. Thousands from the surrounding area were present on September 19, 1907, at 10:00 a.m. when the first parade made its way onto Pine Street, under the new arch, and into the fabled "Tokay City." Awaiting them was food and entertainment of every description, including candies, ice cream, Egyptian corn, a Wild West show, a crazy house, and a parachute jump. It was then that Lodi, christened by the joy of the masses, was truly born. Despite losing $500 on the event, its success and importance was indisputable; even James Gillett, the governor of California, had attended. The carnival brought an enormous amount of attention to the area and forged a unique identity for the town and its inhabitants. The celebration, however, was not repeated the following year. Attempts were made to revive the carnival in 1917 but were dropped at the onset of World War I. It was not until 1934 that the festival returned to celebrate Lodi's glorious grapes. The Tokay Carnival continues today as the Lodi Grape Festival and Harvest Fair, still held every September.

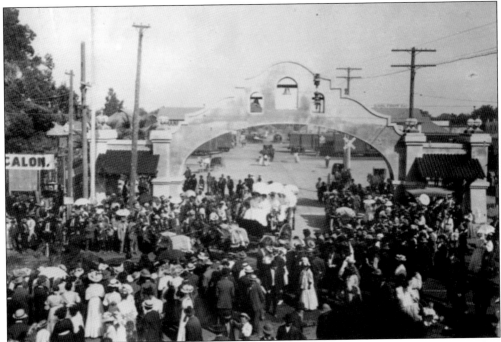

Crowds of spectators watch the parade as Queen Zinfandel's maids-of-honor enter the "Tokay City" under the arch. An estimated 25,000 to 30,000 people attended the three-day event. A large tent city was built from Elm to Oak Streets to help accommodate the revelers. Lodi's regular population at the time was just over 2,000 people. (BSC.)

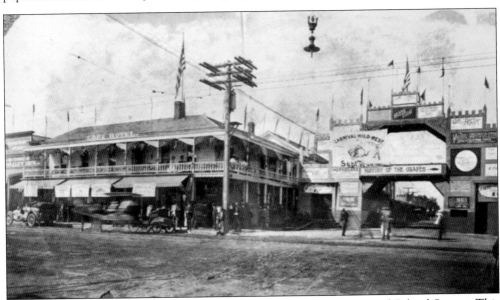

Flags fly over the "fun arch" built on Pine Street between Sacramento and School Streets. This arch featured a bandstand overhead and two 10¢ theaters on its sides. It was constructed by prolific builders Edward and Fred Cary at the same time as the mission arch. Banners advertise local businesses and the upcoming festivities. This temporary arch was torn down at the conclusion of the carnival. (BSC.)

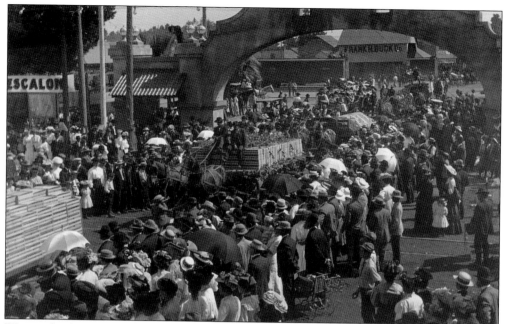

Wagons loaded with crates full of grapes make their way onto the parade route. The purpose for the organization of the carnival was to promote the area as the world's premier Tokay grape-growing region. The Lodi economy would depend on the Tokay grape for years until changing tastes and decreasing demand caused many growers to switch to other types of grapes in the 1970s. (CTC.)

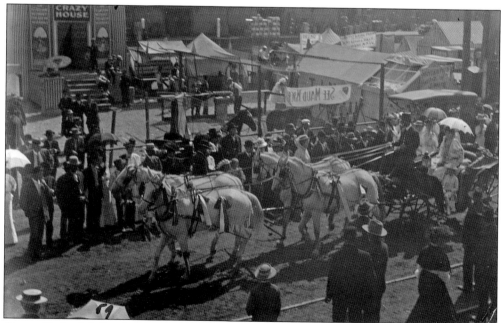

Queen Zinfandel, Bertha De Almado, rides in her royal coach down Sacramento Street past a crazy house set up for the carnival. Entertainment and attractions of all types could be found in the "Tokay City," Lodi's adopted name for the event. The parade made its way through the heart of the city, delighting the revelers in attendance. (CTC.)

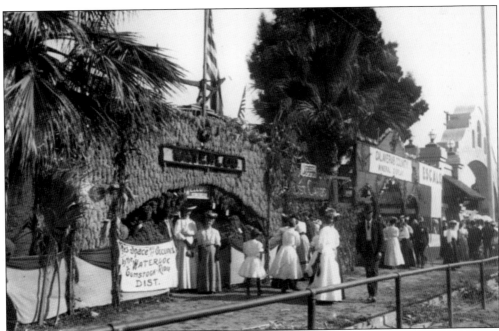

Various towns operated carnival booths in the park north of the mission arch promoting their local industries. Represented in this photograph are, from left to right, the Waterloo Comstock Ridge District, fronted with Egyptian corn and selling postcards, the Calaveras County Mineral Display, which gave away $1,000 in gold specimens, and the city of Escalon's agricultural display. (BSC.)

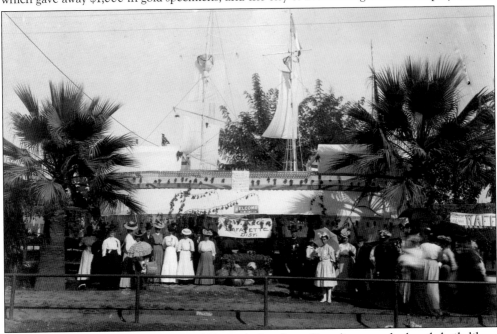

The Lafayette District of the W.A.C. (Women's Auxiliary Corps) operated a booth built like a three-mast ship at the carnival. A Civil War veteran (to the right of the sign) stands next to a smartly dressed unidentified girl. Hundreds of booths were set up in the open area known as Southern Pacific Park to the north of the arch. (CTC.)

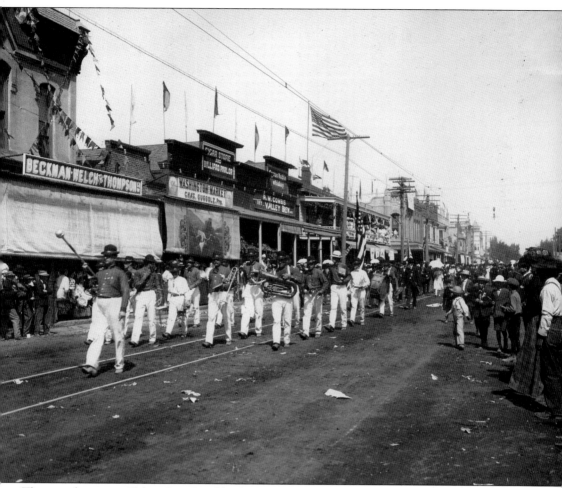

The award-winning Tokay City Band leads the parade processional on the opening day of the carnival. The 22-piece band was a staple of Lodi's early musical scene for more than two decades and was a successful incarnation of a succession of early Lodi bands. The band played at every major event in town and performed throughout the carnival in the fun arch bandstand over Pine Street. John Bauer, an accomplished musician and conductor, had played with the Minneapolis Symphony Orchestra before coming to California. Bauer organized the troupe of musicians for the carnival and throughout the band's career until they disbanded sometime in the 1930s. (CTC.)

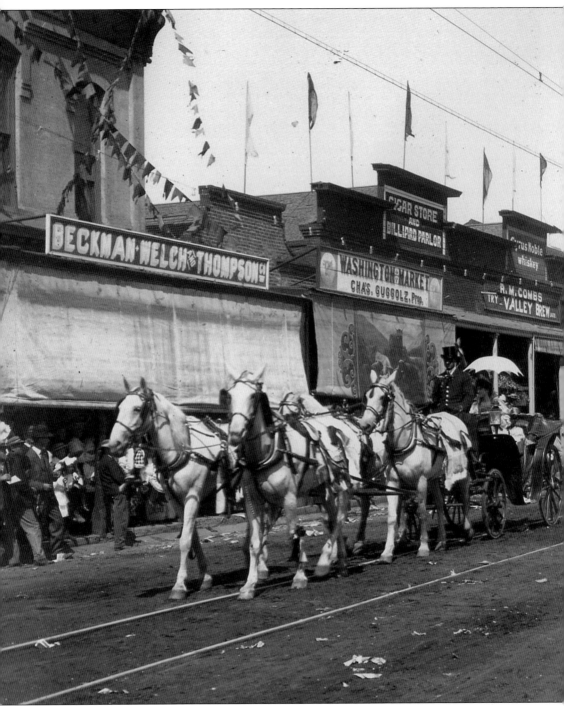

Queen Zinfandel, Bertha De Almado, rides in her royal carriage down a richly decorated Sacramento Street. Her carriage is appropriately pulled by four white horses on the way to her coronation. Her 10 maids-of-honor follow in an impressive four-in-hand tallyho coach. Beautifully decorated wagons and floats followed the royal court in the opening day parade on September 19, 1907. The debut parade was a community affair with everyone from Civil War veterans, grape growers,

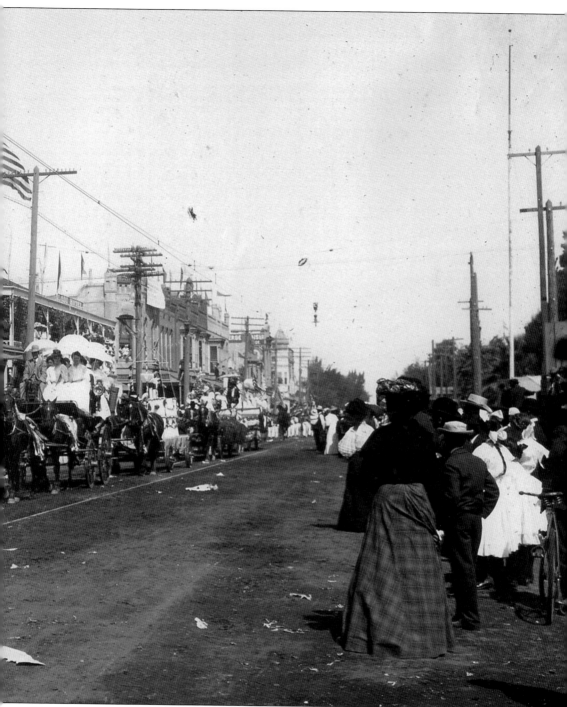

civic organizations, and societies participating. The procession toured through Lodi's prominent streets, finally ending at a lavishly decorated throne where the first queen of the carnival would be crowned. The three days of the Tokay Carnival were filled with excitement and activity, the likes of which Lodi had never seen before. (CTC.)

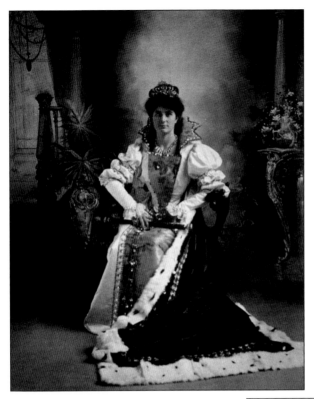

The queen and maids-of-honor were selected by vote in the months before the festival. The public could purchase a ballot for 1¢ from Lodi businesses and then cast them at Ross's Candy Store. When the votes were counted, Bertha De Almado won as queen of the festivities. She was awarded $300 to purchase her royal robes, which were created by a San Francisco costume designer. (BSC.)

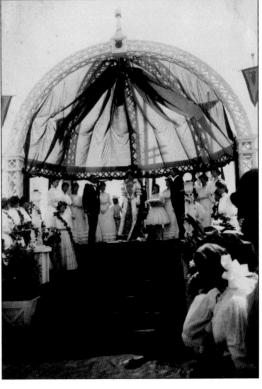

Bertha De Almado stands before her canopied throne as she is crowned Queen Zinfandel at the royal coronation. George E. Lawrence (left), chairman of the board of trade and Lodi's first mayor, gives a speech and presents the queen with the keys to the city, while Charles Ferdun, acting as prime minister, stands at attention. (CTC.)

A delicious bunch of Tokay grapes is featured in this postcard advertisement for the festival. Lodi's citizens actively promoted the event by sending out postcards to garner interest in the festival. It reads: "Mary had a little lamb, At least that's what they say; It only ate Flame Tokay Grapes, It wouldn't eat plain hay." (LLA.)

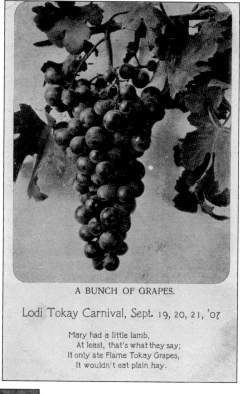

A BUNCH OF GRAPES.

Lodi Tokay Carnival, Sept. 19, 20, 21, '07

Mary had a little lamb,
At least, that's what they say;
It only ate Flame Tokay Grapes,
It wouldn't eat plain hay.

With the repeal of Prohibition in 1933, Lodi was once again ready to celebrate its harvest. Twenty seven years had passed since the Tokay Carnival, but its memory was still fresh in many minds. In 1934, Marie Graffigna was crowned the first queen of this newly organized celebration. The Grape Festival has been held every year except from 1942 to 1945, due to World War II. (BSC.)

73

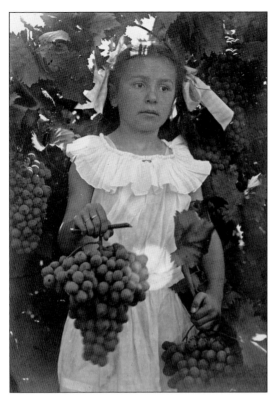

The Tokay Carnival left a lasting impression on Lodi's citizens, including Ralphine Mills (pictured at left), who holds bunches of Tokay grapes as she poses as a grape princess in 1907. The pioneering Mills family arrived in the county in 1857 and became prominent members of the community. Her father, Freeman B. Mills, a respected teacher and farmer, was one of the first men to plant a commercial vineyard in the Lodi area. In keeping with the grape princess tradition, Carrie Tindell (shown below), daughter of Ralphine (Mills) Tindell, poses in 1937 the same way her mother did 30 years earlier. (Both LLA.)

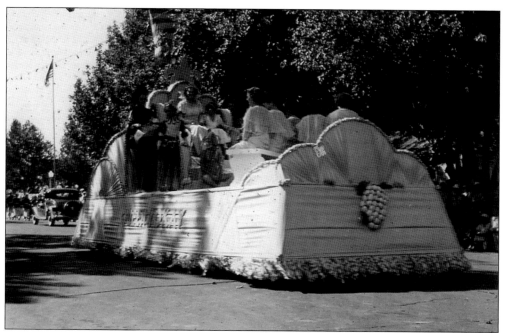

Marie Graffigna (on throne in center) rides with her attendants on a parade float as queen of the Grape Festival in 1934. The official title of Queen Zinfandel was replaced with Queen Tokay for this new festival. The revival of the celebration, complete with parade, was due in large part to the work of Lodi police chief Clarence Jackson. (CTC.)

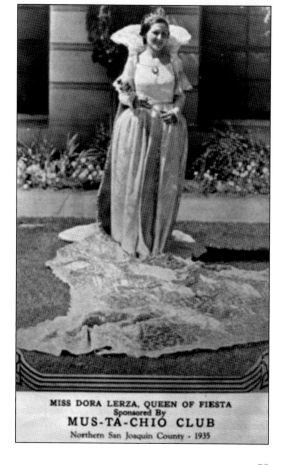

MISS DORA LERZA, QUEEN OF FIESTA
Sponsored By
MUS-TÁ-CHIÓ CLUB
Northern San Joaquin County · 1935

Dora Lerza appears as queen in this 1935 advertisement for the Mustachio Club. This tongue-in-cheek group, under the leadership of Chief Clarence Jackson, was instrumental in organizing the new Grape Festival. In addition to the commitment to grow mustaches, the group worked to raise funds and promote the event. The club retained many ideas from the original 1907 carnival but included many of their own. (BSC.)

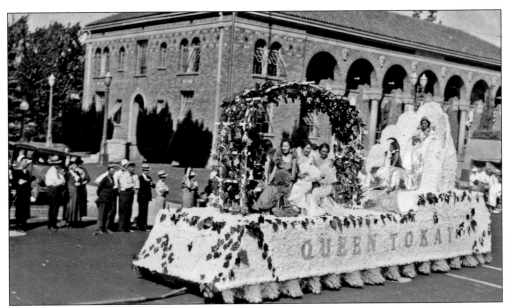

The new Grape Festival featured a "Horribles Parade" where club members dressed in frightening and funny costumes to the delight of crowds. It also incorporated a parade that featured Queen Tokay and her attendants riding on a beautifully decorated float down Pine Street past the city hall. The Mustachio Club handed over control to the more seriously named Lodi Grape and Wine Festival, Inc., in 1937. (CTC.)

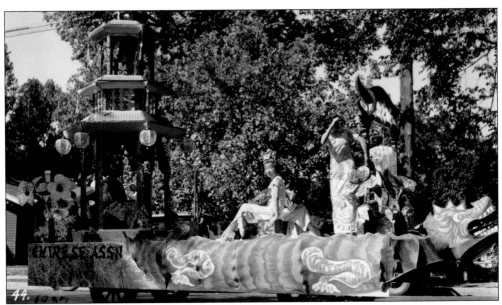

This unique dragon float, built by the local Chinese association, was entered in the parade in 1937, complete with a pagoda-style temple and featuring three Chinese princesses holding baskets of grapes. Entering a float in the parade was a point of community pride and many ethnic, social, and civic groups participated faithfully. (CTC.)

A beautifully costumed Chinese maiden carries baskets decorated with flowers in the 1936 festival parade. Lodi's small but significant Chinese population were avid participants in the community, including Mandarin Meat Market owner Lock Kin On, who marched in the parade every year, even after moving to San Francisco, until his death in 1961. (CTC.)

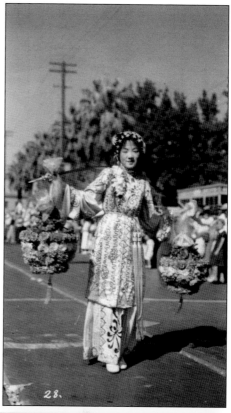

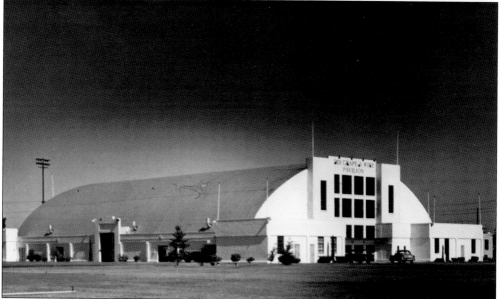

By 1948, officials decided to find a permanent home for the festival. Twenty acres of vineyard were purchased at the corner of Lockeford Street and Cherokee Lane. The Lodi Grape and Wine Pavilion building was constructed and opened in time for the 1949 festival. Also, for the first time in its history, the festival began charging admission. It cost 25¢ to enter the grounds. (LLA.)

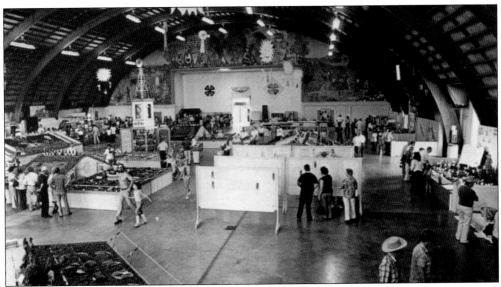

Festival goers enjoy the agricultural and wine displays that abounded inside the Lodi Grape and Wine Pavilion in 1975. A grand painted mural on the back wall depicting an idyllic scene of grape growing through the four seasons was painted in 1950 by famous muralist John Garth of San Francisco. (BSC.)

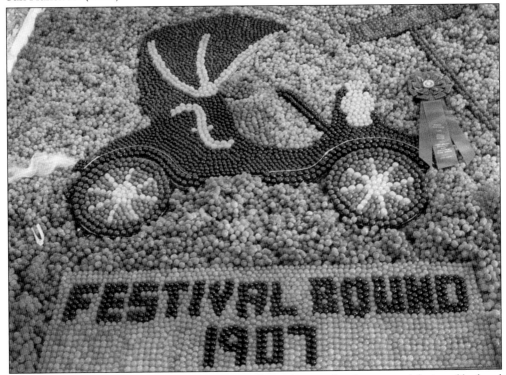

A unique feature of the Grape Festival is its murals, made entirely of grapes and designed by local wineries, clubs, and organizations. This 1982 ribbon-winning mural commemorates the original Tokay Carnival in 1907. Prizes are awarded for this elaborate agricultural artwork as well as for a host of other contests held throughout the event. (BSC.)

A 1975 wine display featuring some local wine producers, including the Wine Growers Guild, the Franzia Brothers Winery, and the Roma Winery, is surrounded by bunches of grapes and flowers inside the Grape Festival Pavilion. Competitions and awards for agricultural displays and produce are a large part of the festival and give San Joaquin County growers a chance to exhibit their hard work to an appreciative audience. (BSC.)

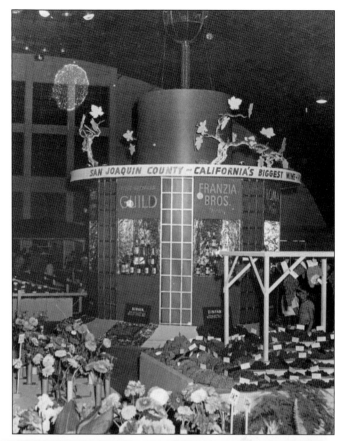

The festival parade was always an important part of the weekend's activities. Families would line the parade route hours before the start to get a good seat. Pictured here is a wacky bottom-dragging car, a recognizable fan favorite for many years, performing its goofy stunts in front of a happy audience. (CTC.)

Lana Mirko, the 1969 festival queen, poses in front of the festival mountain inside the fairgrounds. From the beginning, the queen has served as the face of the festival and has had to perform many ceremonial duties and functions throughout the year of her reign, including publicizing the event. (BSC.)

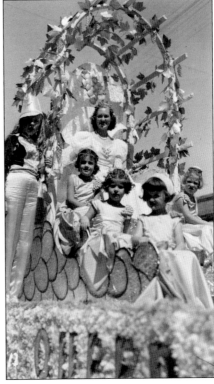

Natalie Bowen, serving as Queen Tokay, sits upon her throne with her attendants in the Grand Parade on Sunday, September 24, 1939. Two parades have always been a part of the festival, the first being a kiddie parade (which replaced the "Horribles Parade" in 1937), which is held on the Saturday of the festival. The Grand Parade, held on Sunday, was the culmination of the weekend's events. (CTC.)

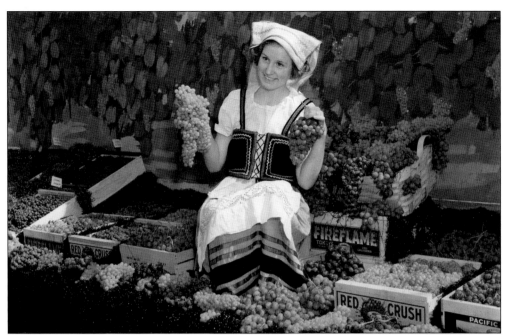

Beautiful women and beautiful grapes have always been a prominent part of celebrating the harvest. Here an unidentified model poses for a publicity photograph for the 1937 festival amid the label boxes of local growers. Several local girls appeared as models in the photographs, which were used on advertisements and in programs. (CTC.)

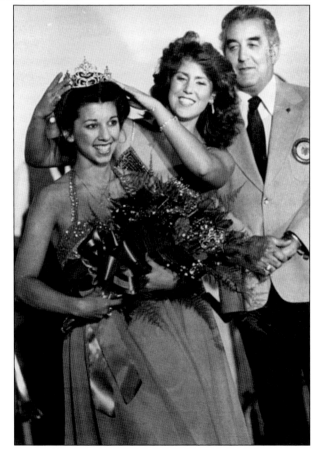

Angela Parises (left) is crowned by out-going royal Bettina Naylor and official Jim Rinaudo as the last Grape Festival queen in 1980. Citing a lack of interest and changing priorities, Grape Festival officials unfortunately decided to eliminate the queen contest and royal court from further festivals. (BSC.)

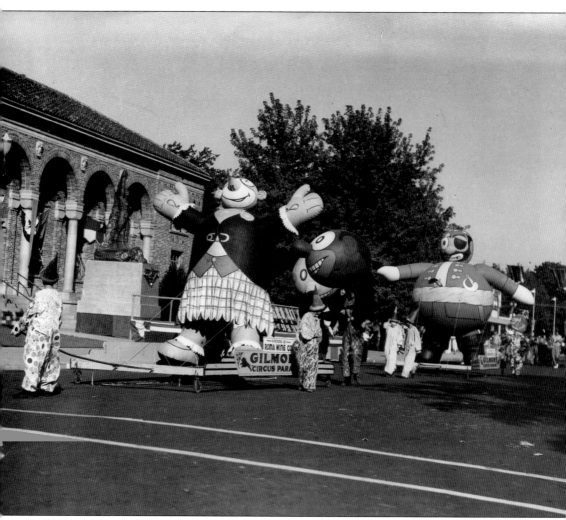

The local Roma Winery, situated east of Lodi and reportedly the world's largest winery in the 1930s and 1940s, sponsored the fantastic Gilmore Circus Parade, complete with balloon characters and floats, in 1936. The procession makes its way down Pine Street past city hall and the Carnegie Library, which had always been part of the customary parade route. Since the beginning, the parade had been a part of the traditional festival activities. In 2002, organizers decided to end the parade, citing a lack of community interest. This move sadly ended the long-running tradition and unceremoniously closed a unique chapter of Lodi's history. (LLA.)

Six

FLOODS, FIRES, AND MAYHEM
DISASTER IN A SMALL CITY

Life in a small, peaceful city can seem ideal. Tree-lined streets and friendly neighbors lend a sense of safety and comfort. Yet life's cruelties and dangers are never far away, and no community can escape tragedy. The first major catastrophe the town faced was the big fire of 1887. On October 11, 1887, a fire started in Martin and Rowland's Planing Mill, and in less than 20 minutes, it spread throughout the entire business district. The losses were devastating; most of the buildings were wooden and were reduced to ash. The town was helpless in the onslaught of destruction. It had not prepared adequately for the threat (as the *Lodi Sentinel* newspaper had warned the community earlier), and it paid dearly. Even the peaceful Mokelumne River has periodically broke its banks and shown its dark side. "The heart of the booming little town presented a desolate picture of devastation and ruin," wrote the *Stockton Daily Independent* during one such incident. The river flooded several times, with large inundations occurring in 1907, 1928, 1950, and 1955, causing tremendous damage to the areas fronting the river. Although natural disasters are alarming, perhaps the most terrifying kind of mayhem is the kind inflicted by man upon his fellows, as in 1911 when a scandalous murder took place on the streets of Lodi. It was then that two community pillars, Samuel Axtell, editor of the *Lodi Sentinel*, and Charles Sollars, owner of the Lodi Soda Works, would cross paths a final time with deadly results. With the idyllic past a faded memory and the world a scarier place, at least the danger of fire has diminished with modern firefighting methods, although floods still remain a significant threat to the area. And as for murder, that dark corner of humanity has never been illuminated, nor is it ever likely to be.

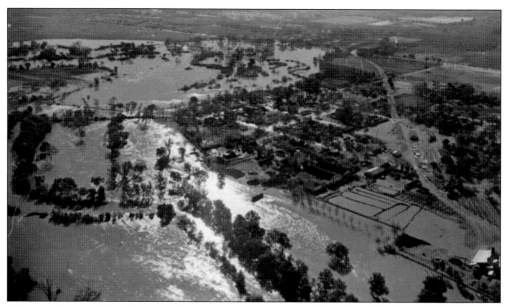

This aerial view of flooding at Lodi Lake in the 1950s was taken by noted photographer Leonard Covello. Water can be seen inundating the homes and farms located near the lake. Lodi Lake has periodically broken its banks, causing significant damage to the area. In the rainy season, the lake is drained to help with flood control. (BSC.)

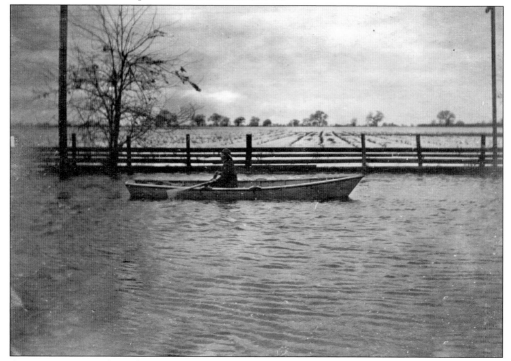

A man is rowing a boat down Woodbridge Road (present-day Turner Road) after the great flood on March 26, 1907. Smith's Lake (modern Lodi Lake) would often flood to varying degrees during the next 50 years. The Woodbridge Dam, constructed in 1910, would help with flood control, but in heavy rain years, flooding can still occur. (CTC.)

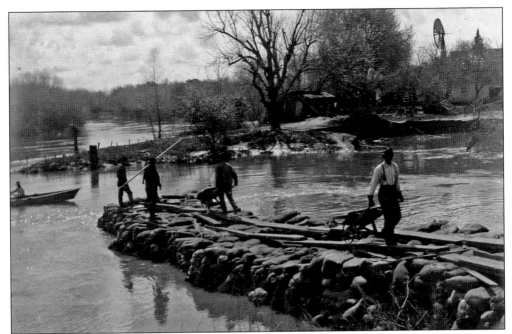

Men repair a levee with sandbags on the Mokelumne River near Woodbridge after the flood of 1907. The Graffigna farm can be seen in the background. Controlling the river has always been a difficult task for engineers and officials. Today the levees are an important part of keeping the flood waters at bay, with hundreds of homes now built in this area. (CTC.)

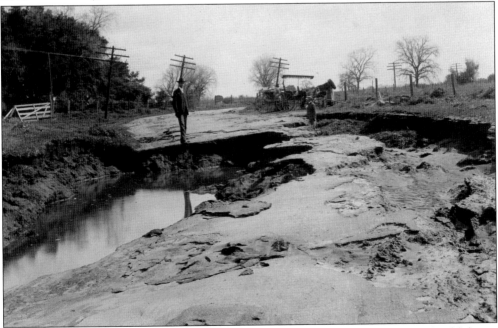

The 1907 flood waters have laid waste to Woodbridge Road, causing sinkholes and landslides on the important thoroughfare. Electric poles lean haphazardly in the background. The man standing (left) on the silt is Wilson Thompson, a prominent local businessman. The person behind the camera is his wife and avid photographer, Celia Crocker Thompson. (CTC.)

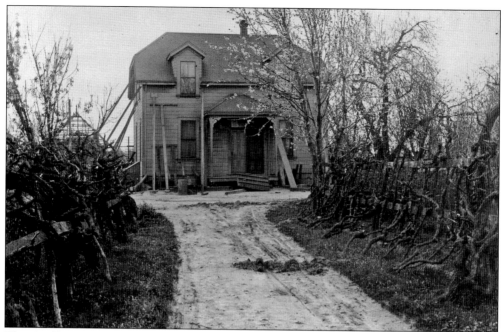

The Graffigna farm suffered serious damage in the flood. Wooden poles and lean-tos support the home and prevent it from toppling over completely. The slow rise of the water helped to prevent serious human casualties in the flood, but property damage to those near the river was significant. (CTC.)

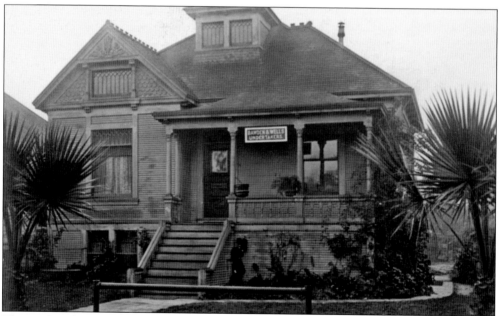

Thomas Bawden and Oscar Wells turned this home on Pine Street into an undertaking parlor in 1909. There they conducted the solemn business of caring for Lodi's dead and operated the first motorized hearse in the county until Bawden left in 1912. Thomas and his wife, Johanna, one of the first women embalmers in California, moved their operation to 123 North School Street. (Steve Mann Collection.)

A blaze behind the Lodi Hotel and Barnhart Building in 1890 is extinguished by a group of volunteer firefighters. Even though this group wields a fire hose, early equipment was often primitive, and the town was dependent on volunteers for protection. This changed on June 11, 1907, when the Lodi Fire Department was organized by Hilliard Welch, who was elected the first Lodi fire chief. (CTC.)

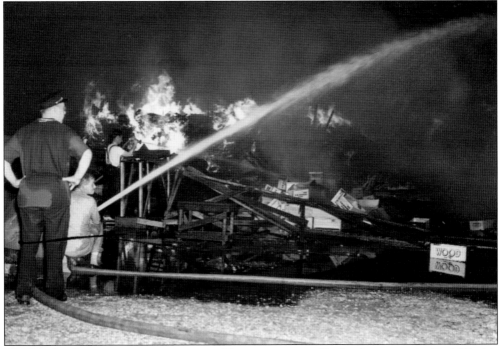

The first fire department was not a successful organization and had to be reorganized in 1911, this time with Ed Stark serving as chief. Stark was a skilled fireman from Minnesota before moving to Lodi. This new group eventually grew into the professional Lodi Fire Department, seen here battling a packing shed fire in 1955. (BSC.)

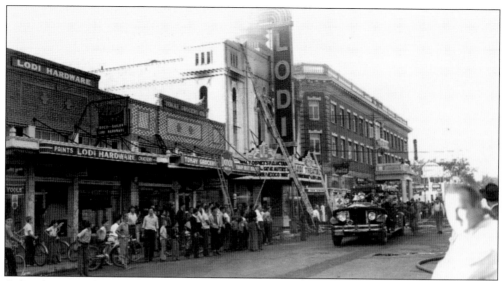

A fire threatens the Lodi Theatre and surrounding businesses on School Street on October 10, 1941. Eight people were injured during a matinee performance of Gene Autry's *Down Mexico Way*. The theater was repaired and back in business for a time until a suspected arson fire completely destroyed the interior and sadly closed the theater for good on June 29, 1962. (BSC.)

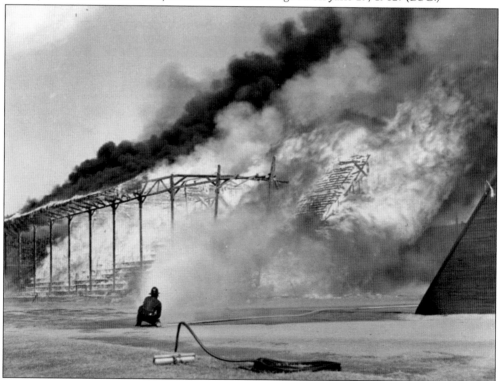

Firefighters battle a raging blaze in the grandstand of the high school east campus (also known as Tokay High School). The Tokay fire of March 14, 1974, was set by two local high school seniors and significantly damaged the structure, which was originally built as Lodi Union High School in 1913. A new Tokay High was built on Ham Lane and Century Boulevard in 1977. (BSC.)

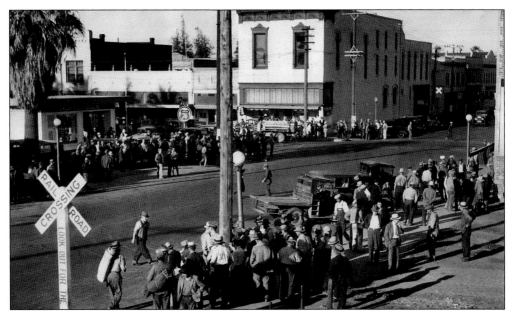

In 1933, striking grape workers hit the streets of Lodi. Protests quickly flared into violence, fueled by out-of-town activists. A vigilance committee was formed by the local police to combat the unrest. Eventually police put more than 2,000 agitators on a Southern Pacific train heading out of town. (BSC.)

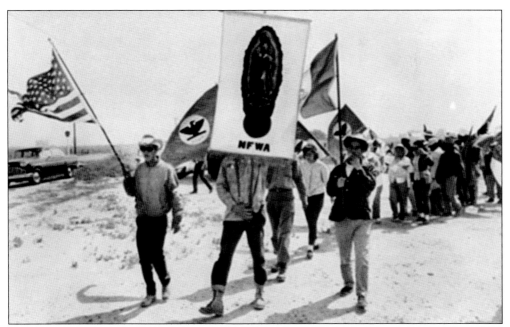

Once again, striking grape workers pass through Lodi on the way to the state capital in 1966. The grape workers carry the banners of the National Farm Workers Association and marched 300 miles, from Delano to Sacramento through Lodi, the heart of California's farming region. This particular march was successful and got several agricultural businesses to recognize their union and negotiate. (BSC.)

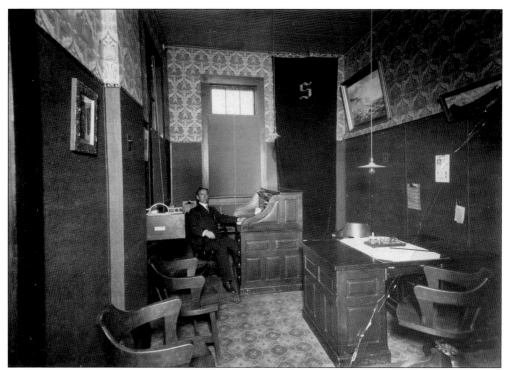

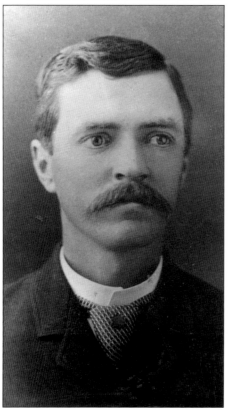

On June 10, 1911, two young Emerson school teachers crashed an automobile that belonged to *Lodi Sentinel* editor Samuel Axtell (pictured above in his office) and his wife, Clara Kettleman. First on the accident scene were Charles Sollars (shown at left), owner of the Lodi Soda Works, and his wife, Anna. Three days later, a scandalous front page article in the *Stockton Mail* speculated that the teachers had an improper relationship with Axtell, which set into motion the tragic events that followed. On June 16, Axtell followed Sollars into the Lodi Garage, produced a pistol, and shot Sollars twice. Sollars died the next day. Axtell believed Sollars had spread the story, although the journalist who wrote the piece testified that he never once spoke to Sollars. Axtell was sentenced to life in Folsom prison but was later paroled. (Both, LLA.)

Seven

THE RAILROAD
LIFELINE OF THE CITY

Perhaps the greatest advancement in the development of Lodi as a settlement came with the iron rails of the Central Pacific Railroad. Only a few scattered farms existed prior to 1869, carved out of the rough brush that dominated the land around the Mokelumne River. The principal settlements of the area had grown around the most reliable river crossings, namely Woodbridge, three miles west, and Lockeford, eight miles east. This changed when the Western Pacific Railroad (later absorbed into the Central Pacific in 1870, which, in turn, became the Southern Pacific in 1885) began to survey for the westernmost portion of the transcontinental railroad between San Jose and Sacramento. Local pioneers Reuben Wardrobe, Allen Ayers, John Magley, and Ezekiel Lawrence, men who had settled the wild land between the north county's two river crossings, approached the railroad men with a proposition. If the railroad would build a station and lay tracks through their land, they would agree to give 160 acres for the town site, plus ownership of every odd numbered lot, and 12 acres in the center of the new town. It was an attractive offer for the best route through this portion of the valley, and so the town and its train station, named Mokelumne after the river, was born. But the spirit of cooperation between the railroad and the county's citizens would not last. Shortly after completion, the railroad claimed titles to sections of a disputed Mexican land grant a full 10 miles on both sides of its tracks, far in excess of the town's boundary. The claim would go all the way to the U.S. Supreme Court and would eventually be decided in the settlers' favor in 1876. Even after losing the court decision, the railroad continued to fight for free land until 1885. Although the railcars greatly benefited local agriculture, the damage was done. The citizens would never again trust the large railroad and would go so far as to try to start their own competing rail line in 1882.

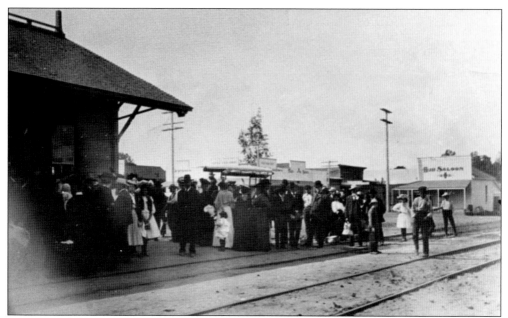

Passengers wait at the Southern Pacific Railroad station in Mokelumne sometime at the beginning of the 20th century. Disembarking passengers could easily satisfy parched throats at the Hub Saloon (the building at right). The new village was officially registered on August 25, 1869, after the completion of the railroad line. The depot was finished in December of the same year. This signaled the start of the town's steady growth. (BSC.)

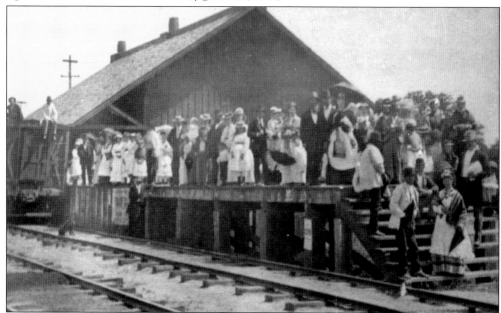

A group of well-dressed passengers wait for a train at the Mokelumne Station after the Los Moquelemos celebration in 1876. Railroad engineers had difficulty building the bridge over the Mokelumne River due to the soft, shifting soil and the river's current. This battle with the bridge recalled to mind another epic Napoleonic encounter, the Battle of Lodi, and may have inspired the changing of the town's name. (BSC.)

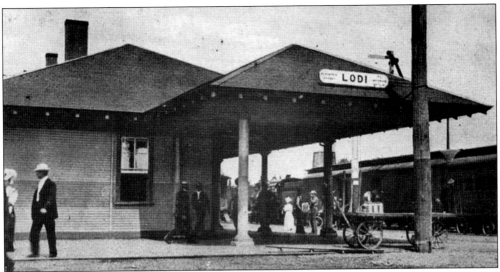

This postcard (above) shows the second passenger depot with the town's new name of Lodi. The depot, at the corner of Pine and Sacramento Streets, became the center of activity for the town. Its name was changed to avoid confusion with the nearby communities of similar names, but when the first train arrived on August 11, 1869, several hundred travelers from Sacramento mistakenly disembarked, believing they had reached Stockton. A signal on a mailbag post would inform waiting passengers when the train would stop. Businesses depended on the railroad, and Lodi quickly became a vital transportation and distribution center (shown below) for this portion of the Central Valley and the Sierra Nevada. (Both, BSC.)

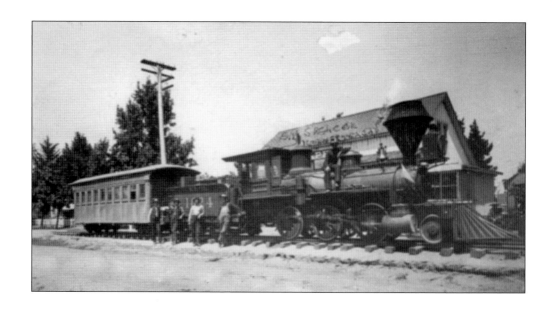

The San Joaquin and Sierra Nevada Railroad was built as a narrow gauge in 1882 to combat the monopoly of the Southern Pacific Railroad and to prevent it from using its standard trains on the narrow line. Established by a group of local grain farmers, it ran from Brack's Landing (10 miles west of Woodbridge) into Valley Springs. Despite best efforts, the Southern Pacific eventually gained control in 1888 and began to convert the tracks to standard gauge in 1904. The No. 2 locomotive, dubbed the *B.F. Langford,* was renamed the No. 1024 (pictured above), which was parked on Lockeford and Sacramento Streets in 1902. The Lodi depot of this railroad was located between Pine and Elm Streets, east of the Southern Pacific tracks (shown below). All service was stopped on the tracks in 1984. (Both, BSC.)

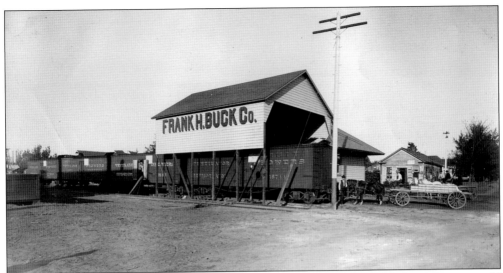

One of the most important benefits of the railroad was the ease with which local farmers could bring crops to market. Farmers had to rely on rough and difficult roads before the railroad's construction. Packing and loading sheds, such as the Frank H. Buck Company, located on the corner of Main and Pine Streets, provided farmers a straightforward way to unload from wagon to rail. (CTC.)

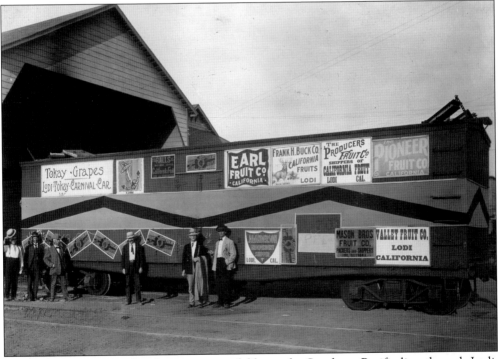

By 1875, refrigerated railroad cars were available on the Southern Pacific line through Lodi, allowing farmers to plant fruit trees, apricots, plums, and eventually grapevines in greater numbers. The *Tokay Carnival Car*, parked at Frank Buck's packing shed, carries advertisements for the upcoming Tokay Carnival in 1907. Proceeds from the sale of the crop in this car were used to help finance the festival. (CTC.)

The Central California Traction Company was started in 1905 to serve as an electric streetcar service in Stockton. Howard Griffiths quickly planned to create a passenger rail system to connect Stockton with Lodi and Sacramento and compete against the Southern Pacific Railroad. The rail line made travel between cities almost effortless, reducing a daylong trip by horse or wagon to only an hour. (BSC.)

The Interurban Electric Line opened for service in Lodi with a celebration on August 31, 1907, in front of the Lodi Hotel. A golden spike was driven, and a bottle of Lodi wine was broken on the tracks down the middle of Sacramento Street. Fares for travel cost 50¢ round-trip or 35¢ one way. (Steve Mann Collection.)

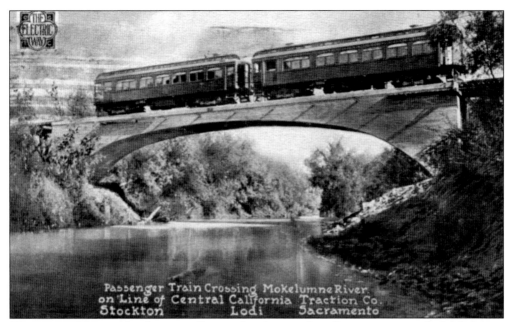

This postcard depicts the electric trolley cars heading north to Sacramento over the Mokelumne River in 1911. The connection to the state capital was completed the year before. The Traction Company was a vital means of transportation for residents. Rural children used them as school buses, and the line, only a few weeks old at the time, brought huge crowds to Lodi for the Tokay Carnival. (Steve Mann Collection.)

Here an electric trolley car can be seen traveling down Sacramento Street in 1912. Passenger service continued on the line until 1933, when the company was split between three competing train companies, a victim of tough economic times. (LLA.)

It can be argued that without the railroad, seen passing through the countryside, Lodi may have been a very different place than it is now. With the rise of the automobile, bus service, and air travel, the railroads, once a vital part of the city's industry and identity, have suffered a significant blow. Consequently, the area owned by the railroad has been subject to neglect, an ironic fate for land fought so strongly for by Southern Pacific. George Tinkham, writing as early as 1923, was of this opinion, "a railroad reservation unfortunately was plotted in the center of the town. And now it is a great detriment to the city and getting worse every year." However, in 2002, passenger rail service returned to Lodi after a 31-year absence. (BSC.)

Eight

THE QUEEN CITY
BUILDING MOKELUMNE INTO LODI

It can be argued that without the railroad there would be no Lodi. But the truth is that the railroad only provided opportunity where a need for a city already existed, and the new town presented an ideal opportunity for those willing to take it. Settlers came, and the first buildings rose on the dirt road corner of Sacramento and Pine Streets. The town of Mokelumne was now a reality. The fire of 1887 threatened to derail the advancement of the town now called Lodi, but it proved to be a boon as residents rebuilt and improved their property. A more permanent brick and stone city replaced the wooden town of just a few years earlier. When the city incorporated in 1906, a new civic spirit was born in its citizens. Efforts were started to make Lodi a modern city. Banks, schools, and infrastructural improvements were discussed and implemented by the city's new board of trustees. The year 1910 proved to be a banner year in building that lasted through the next 10 years. Some of Lodi's most beautiful buildings, such as the Carnegie Library, the Women's Club Building, the city hall, and the Lodi Union High School, were all built at this time. Lodi also purchased the Cary Brothers power plant, which would provide much needed revenue in the years to come. Even through the years of Prohibition and the Great Depression, Lodi matured and improved itself. Streets were paved, lights were installed, and services were increased. As George Tinkham noted in *History of San Joaquin County,* Lodi "excels all other cities . . . in its progress, government, civil pride, splendid churches and schools, handsome residences and social qualities. It owns its own lighting and water plant, 16 miles of fine asphalt streets, sewerage system, handsome little theater, and fine hotel." Today growth is limited by city mandate, reflecting a fear of many Lodians that the city may become a suburb of Stockton; a fear that Lodi's fiercely independent early founders would never have envisioned.

First Pocket Street Map of Lodi

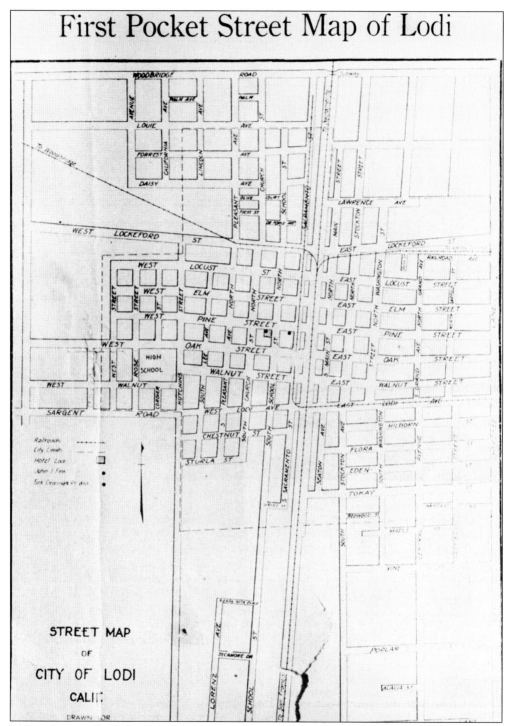

This early map of Lodi shows the city's principal streets planned around the central railroad station located at Pine and Sacramento Streets. Lodi is the northernmost city of California's San Joaquin County and is located south of the Mokelumne River. The original tract for the city covered a half square mile of land, more than 165 acres. (San Joaquin County Historical Museum.)

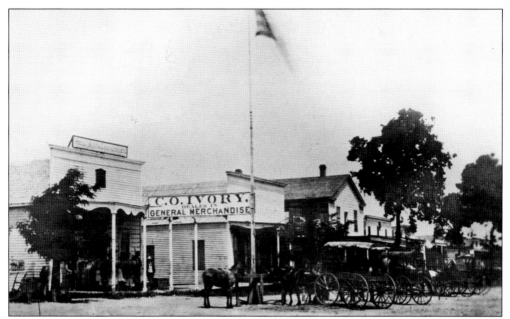

The Charles Ivory general merchandise store is shown on the corner of Pine and Sacramento Streets in perhaps the earliest known photograph of Mokelumne in 1872. Ivory and John Burt moved from Woodbridge and opened the first business in the new town opposite the railroad station only two months after its completion. The prominent flag of the store is in the collection of the San Joaquin County Historical Museum. (BSC.)

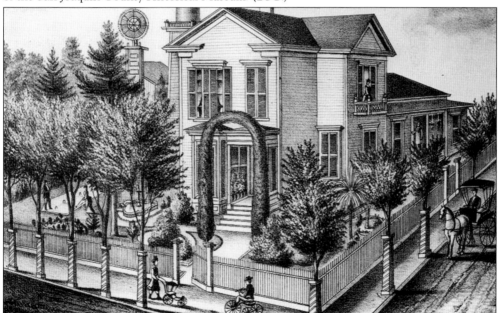

This illustration depicts the residence of Charles and Rebecca Ivory, which was built in 1871 shortly after their marriage. Both the Ivory store and home were built by Isaac Stretch, and the house was one of the earliest and most impressive homes in town. Located at the corner of Elm and School Streets (where the Lodi Cinema 12 Movie Theater is today), the grounds were famous for its trees and elaborate gardens. (BSC.)

This street view, taken in the early 1900s, looks north down Main Street, east of the railroad tracks, and reveals the Keagle Brothers Grocery and Lodging House (right, on corner). Next door is the Joe Hinode Company, a general merchandise store owned by Joe Masui, a prominent Japanese businessman. Main Street was home to many Chinese and Japanese businesses, and still is today. (LLA.)

The traffic on unpaved city streets could raise clouds of annoying dust, so water wagons, like the one seen here, were engaged to water down the streets in the dry summer months to provide some relief. Local builder Fred Cary's residence (left) and the Ivory house (through the trees) can be seen in the background as the wagon moves down Pine Street. (BSC.)

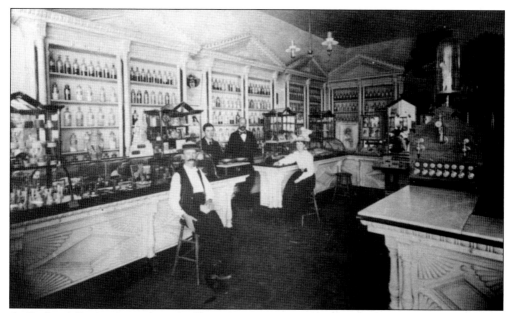

At Graham's Drugstore, residents could purchase medicine, get a soda, mail a letter, send a telegraph, or make a telephone call, and later could purchase tickets for the Central Traction railroad, which stopped outside. Pictured are, from left to right, Harvey Clark (postmaster and librarian), Harry Moore, Robert Graham (the owner), and Blanche Housman (a dressmaker). Graham's was the first pharmacy and business in town with an electric sign. (BSC.)

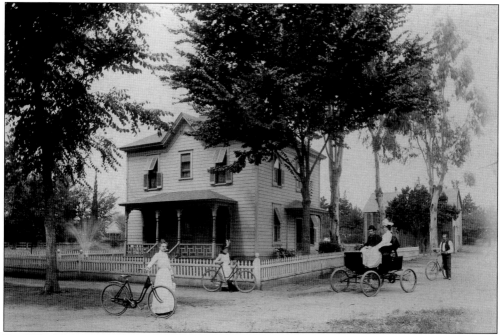

Dr. Wilton Mason was one of the first doctors in Lodi and also the first automobile owner. He purchased the car in order to get to his rural patients more quickly. Mason is seated with his sister Bertha in his Oldsmobile in front of his home, which would later serve as Mason Hospital on School and Locust Streets. (San Joaquin County Historical Museum.)

This farrier (horseshoing) shop was located near the corner of Sacramento and Lockeford Streets and was one of several blacksmiths in town. Colorful signs proclaim the man on the porch as either J. W. Tisdale or possibly a Dr. Segsworth, and promises "scientific horse shoeing" for his customers. (LLA.)

The Binse family operated the Lodi Bakery, located on Elm Street in 1901. The bakery made a popular product known as Dandy Bread for many years until its closing. A painted sign advertising the bread can still be seen on the side of a building on South Main Street looking from Pine Street. (San Joaquin County Historical Museum.)

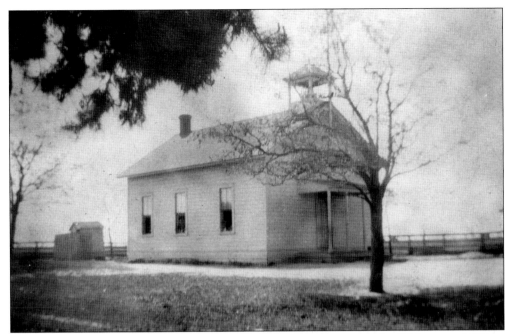

Seen in 1906, the Henderson School was the first school to serve the Elkhorn and Elliott Townships, and was established in a home on Armstrong Road in 1852. Three years later, a one-room schoolhouse was constructed to better serve students. The school building was later moved closer to Lodi on Harney Lane, west of Lower Sacramento Road. (LLA.)

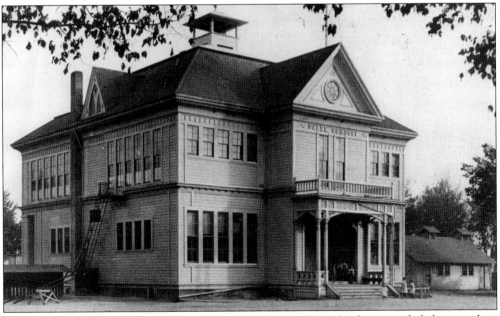

The Salem School was built when locals decided that another school was needed closer to their homes. A one-room school was built in 1859 near modern Highway 99 and the Turner Road crossing. The school was moved twice, in 1862 and 1868, before the town of Mokelumne was established, ending up at the corner of Stockton Street and Sargent Road (present-day Lodi Avenue). (LLA.)

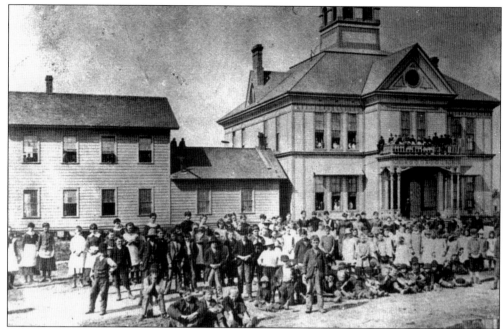

Students surround the addition to the Salem School, which sports a clock tower that was completed in 1883. The two-story building on the left was finished in 1873 and replaced the original building. It would later become a part of the Lodi Hotel. The building in the middle, connecting the two, was called the "kitchen." The school was a source of pride but was torn down in 1938. (BSC.)

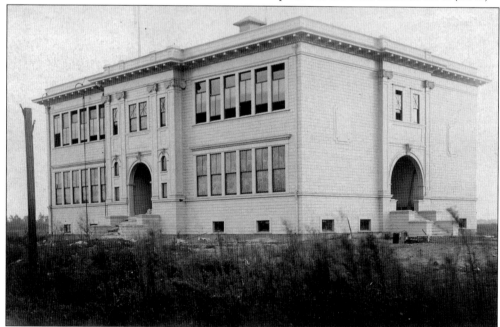

The Emerson Grammar School was a two-story building that had just been completed in this 1907 photograph. Bonds were issued to raise the $25,000 price tag for its construction. The school was later demolished, and today the city-owned Emerson Park is located where it once stood. (LLA.)

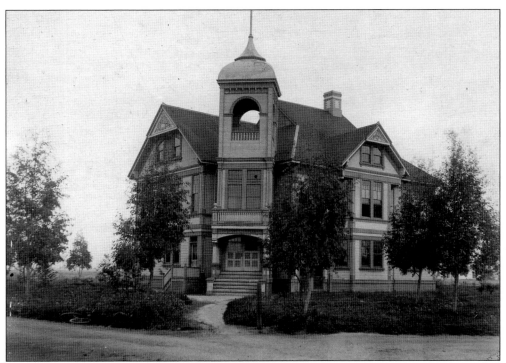

The original high school was located on the upper floor of the Salem School but quickly outgrew its place. In 1900, a new and dramatic-looking building (pictured in 1902) was built on the corner of Lodi Avenue and Church Street by the Cary brothers. In less than 10 years, another new school would be needed for the growing population. (LLA.)

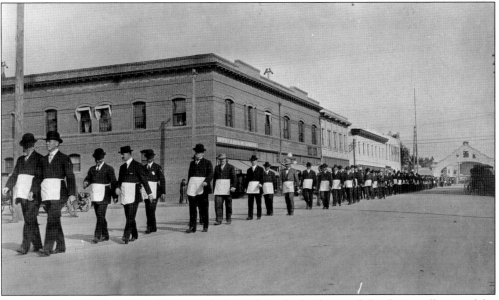

Freemasons march down Pine Street, with the arch in the background, for the installation of the cornerstone of the Lodi Union High School building on February 13, 1913. The California Masonic Grand Lodge conducted the ceremonies. Many prominent men were members of the Lodi Masonic Lodge, and the group took an active part in the development and growth of Lodi. (LLA.)

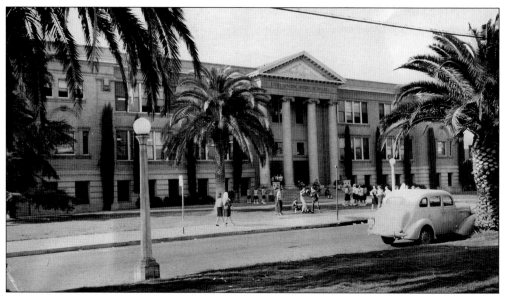

The Lodi Union High School building was an extraordinary structure built in 1913, when the city outgrew the previous high school on Lodi Avenue. The three-story school was constructed on a 12-acre site on Hutchins Street, which, at the time, was outside of Lodi's western city limit. It is now the site of the Hutchins Street Square community center. (BSC.)

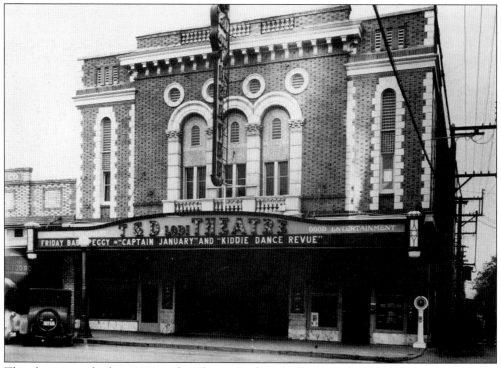

This theater was built in 1918 as the Theatre Lodi and offered residents live theater, vaudeville, concerts, and motion pictures. In 1920, it was renamed the T&D Theatre, and, in 1927, a soda fountain was added to the premises. In 1935, the name was changed once again, to the Lodi Theatre, which it remained until it was destroyed by fire in 1962. (BSC.)

The Lodi Improvement Club was formed by the women of Lodi to help improve the quality of life in the city. They were instrumental in bringing a permanent library to Lodi. In 1913, they became the Woman's Club of Lodi, and in 1923, they built this clubhouse, a beautiful building on the corner of Pine Street and Lee Avenue. It is a popular place to hold events to this day. (BSC.)

Built in 1910 by Dr. Robert Buchanan (standing out front) as the Buchanan Sanitarium, this was the first building of its kind in the city. By 1942, the building at 408 East Pine Street, now known as the Buchanan Hospital, was enlarged and offered 34 beds to sick Lodians. The hospital continued under the Buchanans until 1956, when a group of doctors purchased it and renamed it the Lodi Community Hospital. (BSC.)

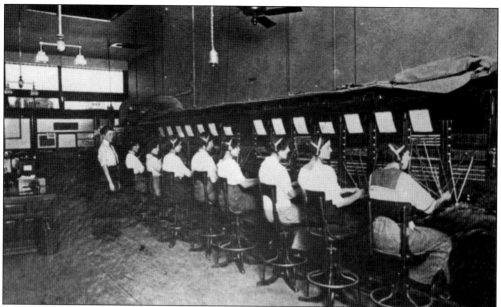

In 1887, the Sunset Telephone Company began operating in Lodi as its first telephone service. Up to this point, the only telephone in town was located at Graham's Drugstore on the corner of Sacramento and Elm Streets. By 1899, the telephone directory listed Lodi with 27 business and 5 residential telephones. The switchboard was operated by local women who would connect incoming calls to the proper receiving party. (BSC.)

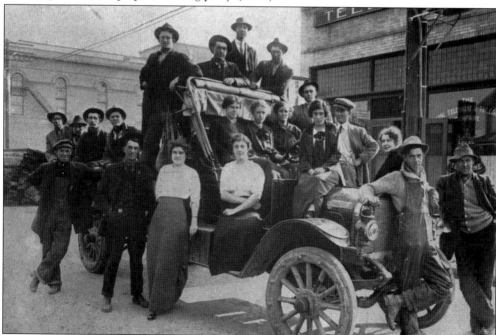

The Pacific Telephone and Telegraph Company took over operations from the Sunset Telephone Company in 1907. Company employees pose on a telephone repair truck in front of their building, which, by 1913, was located at 110 West Pine Street. The installation of telephones connected small communities like Lodi to the wider world and changed the way people communicated. (BSC.)

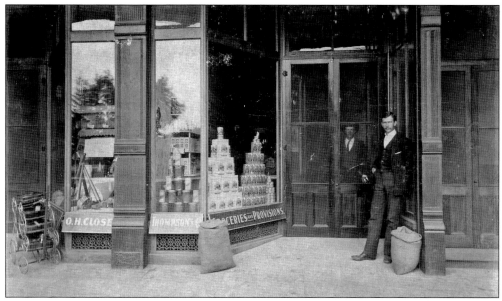

Wilson Thompson, the husband of Celia Crocker, entered the grocery business with William Krause in 1897. At this time, the grocery business on Sacramento Street was a jumble of mergers, sellouts, and partnerships. Later that same year, Thompson (right) opened this store on the corner of Pine and Sacramento Streets with O. H. Close (inside the store) as partner. Krause then sold out to Frank Beckman in 1898. (LLA.)

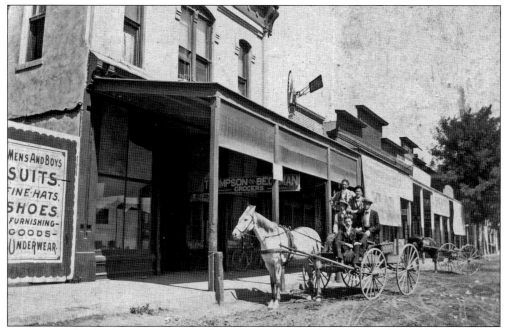

Wilson Thompson (sitting out front), Frank Beckman (standing in rear), and employees sit in a wagon pulled by Polly the horse outside of their store. In 1900, Thompson joined Beckman but left two years later to build his own grocery store next door and then merged into Beckman's store. In 1904, Hilliard Welch became a partner, and the famous Beckman, Welch, and Thompson Company was born. The store lasted until 1929. (LLA.)

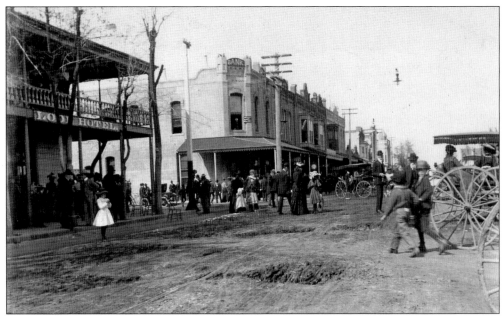

The Lodi Hotel was originally known as the Spencer House, the second and most popular hotel in Lodi. The Sargent brothers bought the place in 1882 and renamed it the Sargent House. After a few rough years of ownership, James Caven purchased the property, refurbished it, and once again renamed it the Lodi Hotel, pictured here around 1890. The girl in the white dress is likely one of the Ivory daughters. (LLA.)

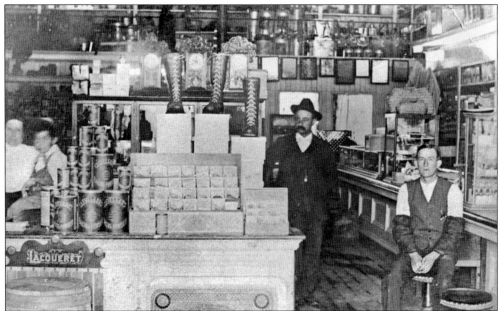

Arnold Friedberger opened the Friedberger and Kaiser Store on the corner of Sacramento and Elm Streets in 1889. The building was originally built in 1876 as the Granger's Building and was one of the few structures to survive the devastating fire of 1887. Inside, Arnold's son Leo Friedberger Sr. (in hat) and grandson Leo Friedberger Jr. (right) work the family business amid the fine selection of c. 1905 merchandise. (BSC.)

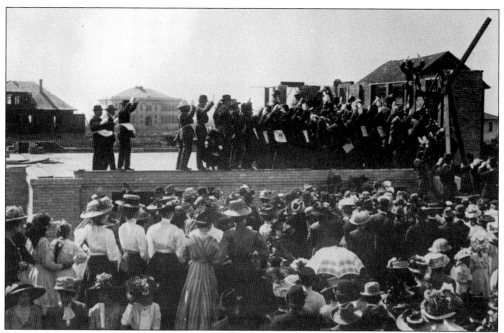

In 1907, city trustees voted to take over operations of the privately funded Lodi Library Free Reading Room, which had been established in 1885, and began working on plans for a permanent public library for the city. On April 17, 1909, the cornerstone of the Carnegie Library was set by the Grand Lodge of Freemasons in front of a large crowd on Pine Street. (BSC.)

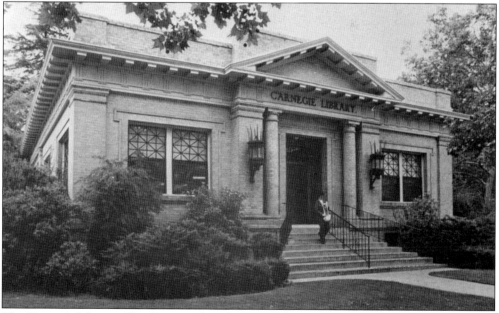

The Carnegie Library officially opened its doors on February 10, 1910. The classic revival–style building was built with a grant from industrialist tycoon Andrew Carnegie and was named in his honor. It served the city until the new Lodi Public Library was built in 1979 on Locust Street. Today the first library building is known as the Carnegie Forum and is the location of city council meetings. (BSC.)

Since its earliest days, Lodi has had a well-represented religious community. Here an unidentified denomination baptizes a member into fellowship in the Mokelumne River. The Methodists were the first organized congregation in the area, with Congregational, Baptist, Catholic, Lutherans, and many more following shortly. Church life got a greater boost when the Russian Germans began to migrate from the Midwest at the beginning of the 20th century. (LLA.)

The Lodi Methodist Church was built on the foundation of the Union Church (which had been constructed to serve all denominations except Mormons) that was destroyed when a candle was left burning unattended. Located on the corner of Oak and School Streets, the church was rebuilt and turned over to the Methodists, the only organized religious group in the town. (Steve Mann Collection.)

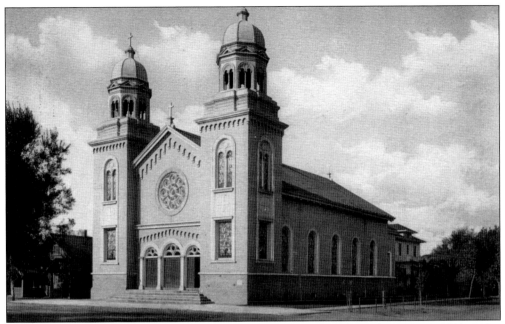

The first St. Anne's Catholic Church was a wooden structure dedicated on May 3, 1891, and is currently located at Central Avenue and Hilborn Street. Pictured here is the second church, a grand structure dedicated on July 27, 1913. The beautiful convent and school were completed in 1922 but unfortunately were demolished when the current church was completed in 1963. (LLA.)

The Congregational Church was organized in 1872, and their first services were held in a barn. In 1879, this church was built on School Street near Lockeford Street and became Lodi's second house of worship. Rev. W. Stewart was the first pastor. He had to ride 10 miles, rain or shine, to officiate. (LLA.)

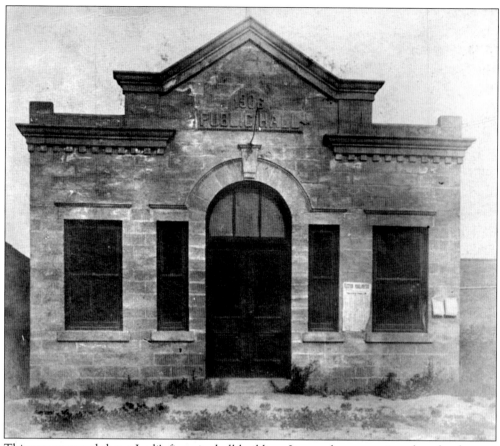

This rare postcard shows Lodi's first city hall building. It served as a meeting place for the new Lodi Board of Trustees in 1906 and had the words "Public Hall" on its facade. It was located on Sacramento Street, north of Locust Street. (Steve Mann Collection.)

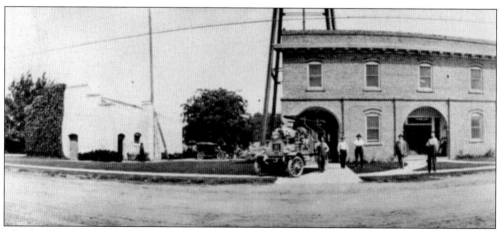

This building served as the second city hall in 1913. It was built a year earlier on Main Street. In addition to serving as the city hall, it was headquarters for the Lodi Fire Department, seen here with a new fire truck that replaced the earlier fire wagons and horses. A new city hall was built on Pine Street in 1928, leaving this building completely to the firemen. (BSC.)

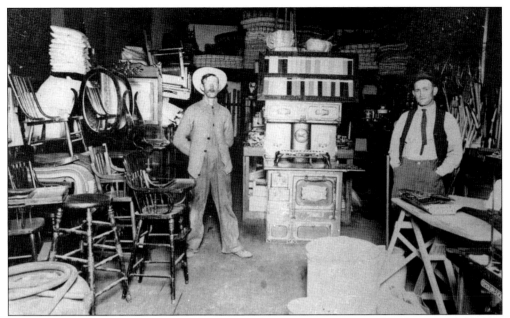

Lodians could purchase or sell any manner of items at Langley's Secondhand Store, which also offered upholstering and furniture repair. The man on the right is possibly William Langley, the owner of the store; the other man is unidentified. This shop was located on Sacramento Street, south of Elm Street. (BSC.)

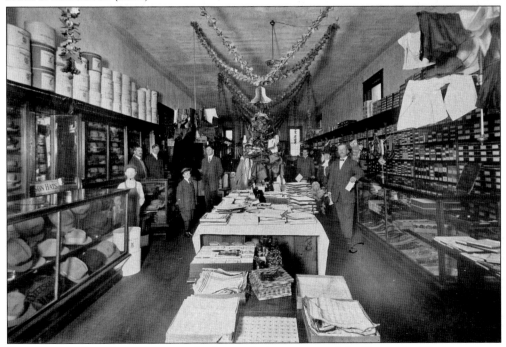

Customers and employees pose inside the men's department of the Enterprise Clothing Store. A fine selection of Stetson hats line the left wall, and various shoes stand along the right inside the Pine Street business. Max Elwert (right) was the proprietor of the business. The store was decorated for the upcoming Tokay Carnival when this photograph was taken in 1907. (LLA.)

The Lodi Opera House was built by Charles Van Buskirk on the corner of School and Pine Streets in 1905. The hall upstairs brought culture to Lodi and featured local and professional plays, dances, concerts, and other entertainments, while downstairs housed shops. The building served as a community gathering place for all manner of meetings and business, including the city's incorporation. (BSC.)

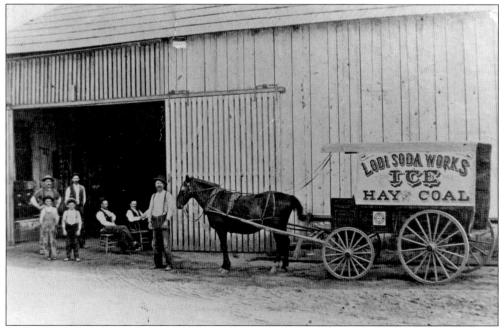

The Lodi Soda Works delivered ice, hay, and coal—staples of life at the time—to residents all over Lodi by trusty horse and wagon and then later by truck. Charles Sollars (seated on right) owned the successful business, seen here some time in the 1890s. Sollars met a tragic end, murdered by Samuel Axtell, editor of the *Lodi Sentinel*. (LLA.)

This beautiful, Queen Anne–style, Victorian home was built by the Cary Brothers for Mary and George Hill, a prominent businessman and Lodi's first jeweler. The home was originally located on School Street but was moved in 1948 to its present location at 826 South Church Street. The Hill family (along with daughter, Nellie, and son, Maurice) lived in the home until 1984, when Maurice willed the house to the community as a museum. Today it serves as the Hill House Museum and is maintained and staffed by the Lodi Historical Society. (Author's collection.)

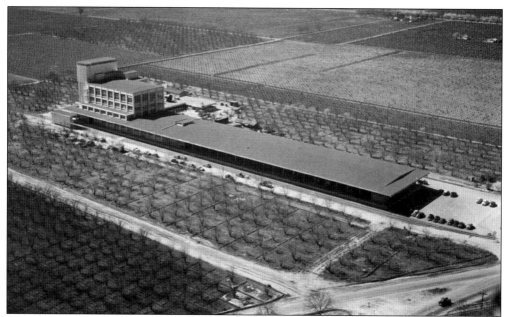

The General Mills Plant, located on Turner Road, was started in 1946 by the Minneapolis-based company and was completed on April 1, 1948, for about $2 million. Originally built on 20 acres of cherry orchard, the plant has expanded to include more than 77 acres. The plant produces Wheaties, Cheerios, Bisquick, and a host of other products, and is one of Lodi's largest employers. (BSC.)

In 1927, the Super Mold Corporation came to Lodi and set up shop in the Atlas Iron Works plant, seen here on Sacramento Street in the 1940s. Super Mold specialized in refurbishing old tires with new tread and brought some economic diversity to the area. The company was highly successful and expanded operations in Lodi and nationally until the company merged, and the Lodi-based operations closed in 1976. (LLA.)

In 1927, William Micke and his wife, Julia, leased a spectacular grove of oaks to the Lodi American Legion for use during picnics. In 1938, they donated the land to San Joaquin County for use as a park and zoo, seen here under expansion in 1952. In 1966, the San Joaquin County Historical Society and Museum joined the complex and have continued its important work of preserving the area's history. (BSC.)

Since its dedication, the 65-acre park has grown into a lovely recreational center. In addition to the beautiful park and 5-acre zoo, Micke's Grove now includes the Funderwoods Amusement Park, a golf course, and the magnificent Japanese Garden, seen here. The Mickes wanted the area children to always have a place to play and enjoy themselves. (BSC.)

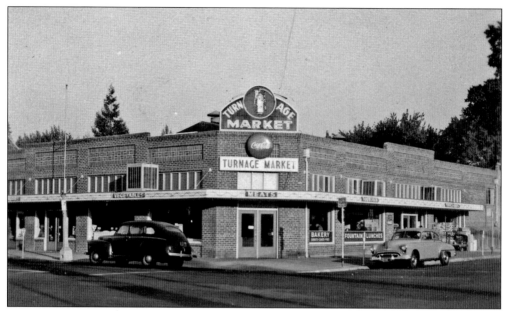

The Turnage Market was a popular spot for locals for many years. Located on the northwest corner of Pine and Church Streets, customers could stop in and get lunch or a fountain soda, as well as do some grocery shopping. The building was demolished and is now a city hall parking lot. (LLA.)

The Hotel Lodi was completed in 1915 on School Street and replaced the Lodi Hotel as the city's premier hotel. When finally completed, it was considered one of the finest hotels in the county. It was modeled after the St. Francis Hotel in San Francisco. Every modern convenience could be found, including private bathrooms, shower baths, and a telephone in every room. (LLA.)

Nine

THE FUTURE LODI
MAKING TOMORROW'S HISTORY

As Lodi hurdles into the 21st century, many new challenges await its residents and leaders. How does the city maintain its quality of life and still remain modern, dynamic, and vibrant? The issues of growth and redevelopment are the hot-button issues of the day and are likely to remain so for the foreseeable future. And, as always, economic issues will determine much of the city's health and vitality. Agriculture will undoubtedly continue to play a large role in Lodi's future as the importance of farming is reemphasized. Agritourism is becoming increasingly important as the area's reputation as a strong wine-producing region continues to be recognized by the wider world. Embracing Lodi's agricultural heritage, while also building and establishing other industries, will take the city far into the future. Prosperity can come from the economic diversity and opportunities that Lodi has to offer. Preserving Lodi's distinct identity as a city is also paramount to its survival. Lodi must embrace its history and civic pride if it is to keep from becoming a bedroom community for the Bay Area or just a northern suburb of Stockton. The founders of Mokelumne in 1896, and then Lodi in 1906, could hardly have imagined the changes that would take place during the 100 years of the city's existence. Despite all the changes, much remains the same: a one-of-a-kind city that provides an extraordinary quality of life for its residents. However Lodi proceeds in whatever direction it takes, what remains true is that Lodi's history is not finished. After all, as Winston Churchill put it, "The farther backward you can look; the farther forward you are likely to see." It remains to be written by its residents and will continue to be as long as people stake their future in this livable, lovable city next to the Mokelumne River.

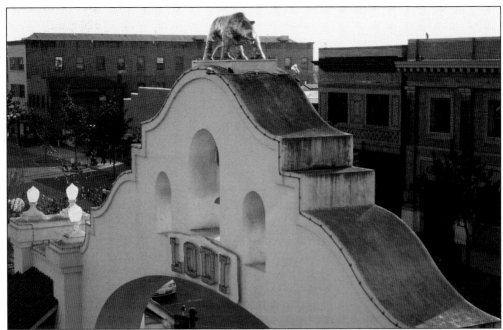

Modern Lodi remains a desirable place to settle despite the popular Creedence Clearwater Revival song that laments, "Oh, Lord, stuck in Lodi again." For residents who actually know the city and its history, nothing could be better. The 21st century will be an exciting and prosperous era for the city with strong leadership and renewed desire on the part of residents. (Author's collection.)

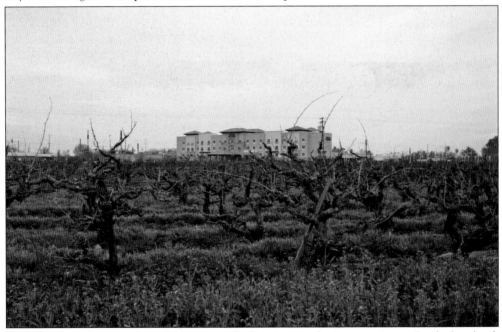

Growth remains a major concern for many Lodians as new businesses rise on fertile farmland, seen here east of Highway 99. With new development comes increased economic potential but at the high cost of decreasing farmland. Lodi's future will be decided, just as it was 103 years ago, by committed residents both old and new. (Author's collection.)

Shades of the past echo on Sacramento Street as many of the buildings retain much of their historic character. Attempts at revitalizing Lodi's downtown are ongoing and are essential to preserving the city's shared heritage. The arch can once again serve as a unique entrance to a revived and rejuvenated city center. (Author's collection.)

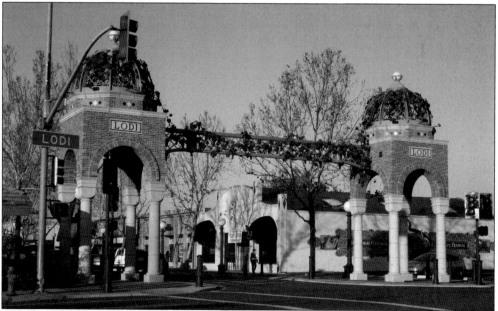

Lodi built a second arch at School Street and Lodi Avenue in 1998 to serve as an entrance to a newly beautified downtown. To celebrate the centennial birthday of the city, several murals were painted throughout Lodi depicting scenes from its history. The one seen here honors the 1907 Tokay Carnival. Lodi must appreciate its historical roots to continue to be a vibrant city. (Author's collection.)

With the creation of the Lodi appellation in 1986, wine-based tourism has provided great economic benefit to the city. In 1991, the Lodi-Woodbridge Winegrape Commission was established to develop this growing business, and the commission recently opened its Discover Lodi Wine and Visitor Center at 2545 West Turner Road. Today Lodi is responsible for more than 18 percent of California's total wine grape production, more than Napa and Sonoma Counties combined, and leads all other wine districts in production of the top five premium wine varieties. But Lodi is so much more than just grapes and wine, with a growing arts scene, represented by the Lodi Arts Commission, and a whole host of events that encompass a multitude of activities. Yet despite its diverse population and interests, Lodi remains, in essence, an agricultural city and continues to work hard to retain a community-oriented, small-town feel. Lodi has much to be proud of and so much more to come. (Author's collection.)

About the Organizations

Most of the photographs in this book were generously provided by these fine organizations dedicated to preserving Lodi's history for future generations:

BANK OF STOCKTON was founded in 1867 and has served the community for more than 140 years as a pioneering financial institution. In 1990, the bank acquired the collection of Stockton photographer and historian Leonard Covello, and now the Bank of Stockton Historical Photograph Collection contains more than 20,000 images in its archives.

LODI PUBLIC LIBRARY was established as early as 1885 for the benefit of city residents (see page 113). In addition to its circulating collection, the library contains a part of the Celia Crocker Thompson Collection of journals and photographs donated to the library for preservation.

SAN JOAQUIN COUNTY HISTORICAL SOCIETY AND MUSEUM was established in 1966 to collect and exhibit artifacts and ephemera significant to the development of San Joaquin County. The San Joaquin County Historical Museum is located inside the Micke's Grove Park and Zoo complex.

LODIHISTORY.COM was founded by the author to provide an online resource for the community of Lodi, California, to explore and learn more about its shared history and civic pride.

ACROSS AMERICA, PEOPLE ARE DISCOVERING SOMETHING WONDERFUL. THEIR HERITAGE.

Arcadia Publishing is the leading local history publisher in the United States. With more than 5,000 titles in print and hundreds of new titles released every year, Arcadia has extensive specialized experience chronicling the history of communities and celebrating America's hidden stories, bringing to life the people, places, and events from the past. To discover the history of other communities across the nation, please visit:

www.arcadiapublishing.com

Customized search tools allow you to find regional history books about the town where you grew up, the cities where your friends and family live, the town where your parents met, or even that retirement spot you've been dreaming about.